Painting Still Lifes *In Watercolor*

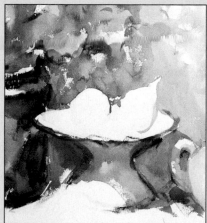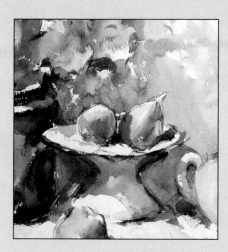

JOSE M. PARRAMON

Watson-Guptill Publications/New York

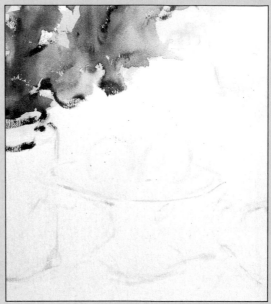
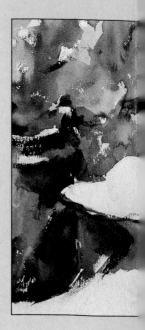

Library of Congress Cataloging-in-Publication Data

Parramón, José María.
 [Pintando bodegón a la acuarela. English]
 Painting still lifes in watercolor / José M. Parramón.
 p. cm.—(Watson-Guptill painting library)
 Translation of: Pintando bodegón a la acuarela.
 ISBN: 0-8230-3866-1
 1. Still-life in art. 2. Watercolor painting—Technique. I. Title. II. Series.
 ND2290. P3713 1991
 751.42'2435—dc20 90-49323
 CIP

Manufactured in Spain
Legal Deposit: B-35.180-90

1 2 3 4 5 6 7 8 9 / 95 94 93 92 91

Painting
Still Lifes In Watercolor

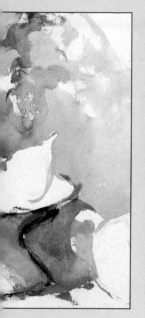
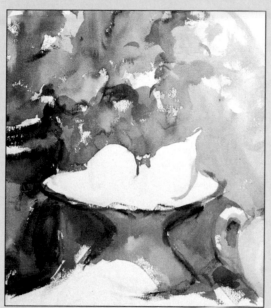
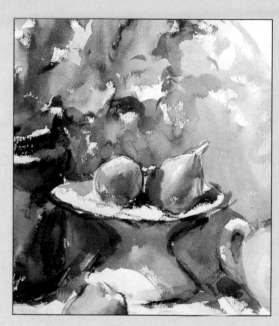

The Watson-Guptill Painting Library series is a collection of books that guides the student of painting and drawing through the work of several professional artists. Each volume demonstrates the techniques and procedures required to paint in watercolor, acrylic, pastel, colored pencil, oil, and so on, within a given theme: landscapes, still life, figures, portraits, seascapes, and so on. Each book in the series presents an explanatory introduction followed by lessons on painting that subject. In this book, *Painting Still Lifes in Watercolor*, we will develop, through examples, the composition, value, and color relationships. Each volume reviews the techniques belonging to the medium in question.

The really extraordinary aspect of this series is its comprehensiveness. All the lessons cover the choice of theme, composition, color, interpretation, as well as color harmony, the effects of light and shadow, color value, and so on. All this knowledge and experience, along with the techniques, secrets, and tricks are provided by several professional artists. All are explained and illustrated line by line, brushstroke by brushstroke, step by step, and illustrated with dozens of photographs taken while the artist was painting the picture.

I personally directed this work with a team that I am proud of. I honestly believe this series of books teaches you how to paint.

José M. Parramón
Watson-Guptill Painting Library Series

The Catalan Association of Watercolor Painters

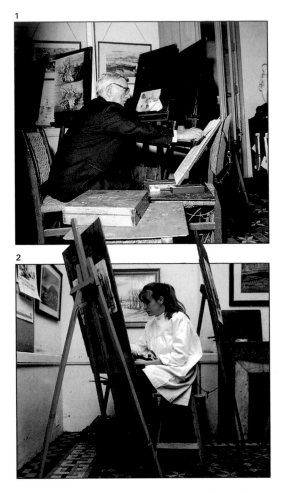

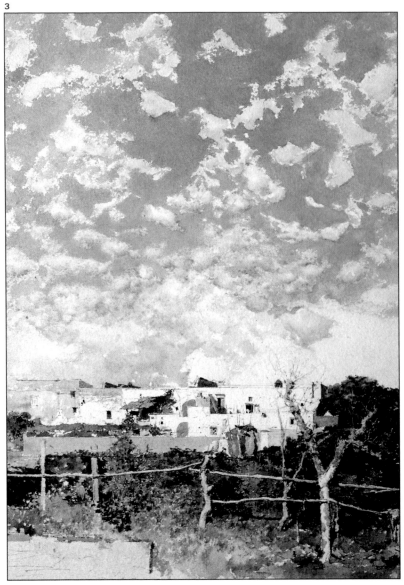

This introduction is devoted to those people who love painting and wish to know more about it, and especially to those who are learning to paint. This introduction is special because it has been carried out by those who are learning, the pupils, and the teachers who teach them.

We find ourselves in one of the oldest associations of watercolor painters in Europe—the Association of Watercolor Painters. It is the meeting point for most of the watercolor artists in Barcelona.

The Association of Watercolor Painters was founded in the year 1865 as the Watercolorists Center. Its foundation was due primarily to the efforts of the internationally famous artist Mariano Fortuny (1838–1974). Some say, with regard to Spanish painting, that Fortuny fills the gap in the nineteenth century between Francisco José de Goya (1746–1828) and Pablo Picasso (1881–1973).

Fortuny not only helped to found this association, he also gave watercolor painting the drive it needed to be considered true art, and a real and vigorous painting technique in Spain, France, and Italy.

Figs. 1 and 2. Some of the students who attend Martín Antón's class in the Catalan Association of Watercolor Painters.

Fig. 3. Mariano Fortuny. *Paisaje.* 16 inches × 12 inches (40 cm × 31 cm). Prado Museum, Madrid. This is one of the influential works that prompted the art world to accept watercolor as a legitimate technique. The use of watercolor spread throughout France, Italy, and Spain from the middle to the end of the nineteenth century.

Watercolor: A short history

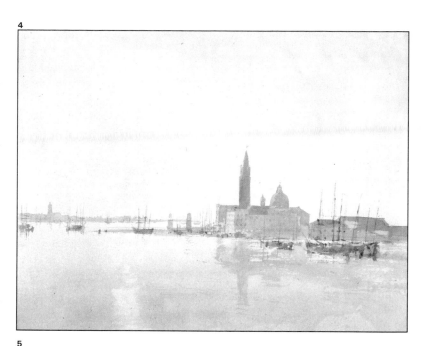

Watercolor painting is an ancient technique of Egyptian origin (it appears in papyrus illustrations) that was introduced to the West in the sixteenth century, mainly by the German painter and engraver Albrecht Dürer (1471–1528).

Two factors contributed to watercolor's later development: its use by publishers in travel books to "illuminate" or to "color in" the images in the drawings; and the attention it received from artistic circles, when used by such talents as the Englishman Joseph Mallord William Turner (1775–1851) and the Frenchman Eugène Delacroix (1798–1863). Turner, a fantastic colorist, was considered by the impressionists to be their forerunner. Delacroix used this technique for a notebook of sketches on Moroccan themes (sketches that he later used in his passionate, romantic, and impressive paintings of biblical and historical themes).

For these reasons, the technique began to be taught in the art schools and be seen in the Western museums. It was, therefore, a combination of its "usefulness" to the nineteenth-century publishing houses for book illustrations (remember this was before photography had come into existence), and the artistic prestige gained by the great painters using watercolor that gave the technique the respectability it needed. Subsequently, with impressionism, the Eastern influence reached us: the ink and Japanese water drawings further established the artistic value of watercolor.

Fig. 4. Joseph Mallord William Turner. *Venice: Saint George from the Customs.* Tate Gallery, London. Painted on his last trip to Venice, this watercolor may be considered one of his most creative works. For Turner, watercolor was a means of expressing atmosphere and light.

Fig. 5. Albrecht Dürer. *The Mound (grasses).* Dürer used watercolor for his travel sketches, for his painting projects, and for his perfectly executed paintings of animals and plants. He was the first Western artist to paint in watercolor since the Middle Ages.

Watercolorists of the Association

We are now at the Association of Water-color Painters. As we have mentioned, this is where professionals and students gather. Let us now present some of the works of several artists who belong to this group and some who also teach there.

This is the case of José Martín Antón, the artist we have invited today to show us how he paints a still life in watercolor. He will also comment on the work of his pupils for us. The works shown here are those of Manel Plana, Ceferino Olivé, and Carmen Barrios. This is only a sampling of the possibilities that watercolor painting offers us.

In the chapters of this book, you can follow the work of some of these watercolorists: José Martín Antón, Dolors Raich, Amadeu Casals, and Manel Plana.

Fig. 6. A still life by Manel Plana. A daring composition—a large number of whites and maximum use of the transparent qualities of watercolor is made.

Fig. 7. A watercolor painting by Ceferino Olivé. This work, unlike the previous one (fig. 6), uses much denser watercolors. It possesses quality and texture close to those of oil painting.

Fig. 8. A watercolor painting by Carmen Barrios. Here the artist takes a valuist approach to the subject: *chiaroscuro* determines the volume of objects.

Fig. 9. A refreshing study in watercolor by Martín Antón. In this work, the technique is used as a quick way of expressing—suggesting more than explaining—the situation and the shape of the objects.

6

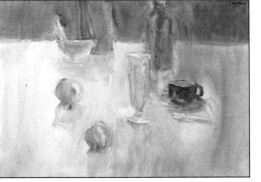

7

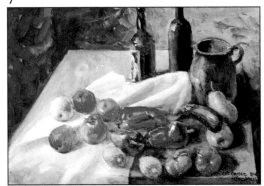

8

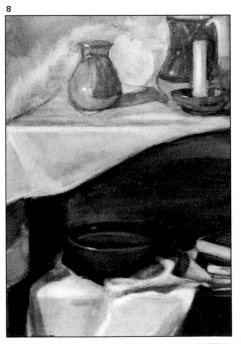

9

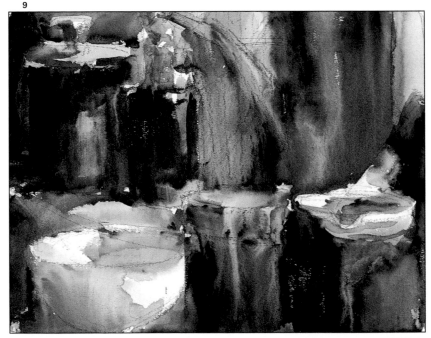

The theme in the studio: Still lifes

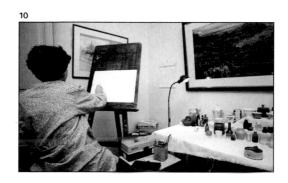

10

We are now going to situate ourselves in a place we may really feel close to: the students' studio workshop.

The work of all the artists around us stems from a single theme: still lifes. Here we may comment at length on the validity of this theme, a validity emphasized by Vincent van Gogh (1853–1890) and Paul Cézanne (1839–1906), both of whom took into consideration the easy access to the subject, the simplicity of changing the lighting or its position, and the simplicity of the almost geometrical shapes involved (vases, plates, fruit, flowers, and so on). It is certainly a very suitable theme for the studio, as many of the problems of drawing and composition that arise in landscape or figure painting are greatly simplified, enabling us to devote ourselves entirely to the pictorial problems.

We are struck by the fact that Martín Antón does not arrange the objects that will make up his still life in any specific way. The setup is composed of a group of objects, perhaps twenty or thirty, that are adjacent in the same plane, or superimposed on different planes. The pupil should choose from these the number and the type of elements that are most suitable for the composition of his or her study.

11

Figs. 10 and 11. Setups composed of many objects. The pupils can close to or far away from the subject and choose the portion of the setup that will make up their composition. They are able to manipulate, if they wish, the size of the objects in their pictures in relation to their real sizes.

Fig. 12. Paul Cézanne. *Still Life of Blue Jar*. Norton Timon Collection, Los Angeles, California. Cézanne said that all the shapes in nature could be reduced to simple geometric shapes. He felt that the still life was a complex enough subject to study pictorial problems, while being, at the same time, simple enough to enable the painter to maintain control.

Fig. 13. Vincent van Gogh. *Imperial Crown in a Copper Vessel*. 1886. Orsay Museum, France. "It has occurred to me," van Gogh wrote in a letter to his brother Theo, "that I could give painting classes to earn a living, I would begin by teaching how to paint still lifes."

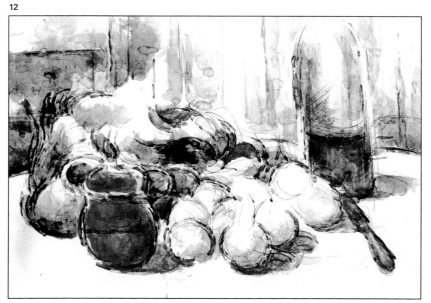

12

13

Composing a painting

Martín Antón's pupils, the people who attend lessons at the Association of Watercolor Painters to learn to improve their watercolor painting technique, have been kind enough to show us some of their works. With these works as a starting point, we shall consider some of the important subjects for learning painting in general, and for painting with watercolor in particular: composition, value, color, and pictorial treatment.

rather like a starting point from which the relevant variations can be made.

Plato wrote that composition is "variety within unity." This is why a composition of this kind—unitary—forms a good basis for the overall success of the picture. Small changes may be made within the general scheme (in this case, a triangle), by adding objects "outside" this triangle. This is only one of a thousand ways of creating "variety within unity."

Fig. 14. Maribel Jarque shows us her composition in this watercolor. The objects are effectively laid out on the paper, forming a symmetrical, but not centered, triangle or pyramid. The background and the brown bottle merge into one another due to their darker tones, forming a "frame" that surrounds this central "triangle."

14

15

Where shall we begin the painting?

First, we choose the subject and select the detail that we are most interested in. We then arrange this detail—its components—on the paper (or the cloth). This is our composition. It is, therefore, the order or harmony of the different elements, in an overall sense, that we want to (and should) give to the picture.

We have chosen two works by Martín Antón's students as examples of different kinds of compositions. In the first (fig. 14), we see that the objects most emphasized by light and color are laid out in the form of a triangle or pyramid. Note that it is not a geometrically perfect triangle, but rather the "suggestion" of a triangle. These pyramid-shaped compositions appear in figure paintings (in the Renaissance, for example), in still lifes, and even in landscapes. This occurs because any composition that has as its base a compact and more or less geometrical shape results in great internal coherence;

16

Fig. 15. A composition by another of Martín Antón's students, Helena Roig. In this case, the elements are distributed in a more complex way, although the "unity within variety" (as Plato would have said) is obtained largely due to the yellow color of the cloth that brings all the elements together.

Fig. 16. A daring, but successful composition by Aroca Rivera. The objects form a diagonal line, dividing the picture from the top left-hand corner to the lower right-hand corner, reinforced by the sloping plane of the bench or box that appears on the left.

The second example shows a more complex and varied composition (fig.15). Strangely enough, there still exists a pyramid scheme. The vertex of the pyramid is the neck of the dark bottle, but it is broken by the curve of the basket handle, by the horizontal line of the yellow cloth, and by the varied shapes of the objects that break up the basic lines. A composition of this kind will be successful when the relationship between the objects (that is, the unity) has been worked on through color or lighting, for example. In the case of this painting, the yellow cloth creates a large surface of color that virtually unites and brings together all the elements of the composition so that none of them appear superfluous or set off from the painting as a whole.

This goal, achieving unity through color, was widely sought by Cézanne. This is therefore another means of achieving "variety within unity." On this page we show a still life by Cézanne and another by Giorgio Morandi (1890–1964), both with very different, but fine compositions. You should try to guess why these pictures work so well compositionally, regardless of their subject matter.

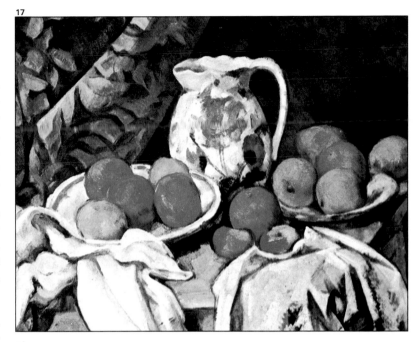

17

18

Fig. 17. Paul Cézanne. *Still Life with Curtain*. Hermitage Museum, Leningrad. Paul Cézanne was, among other things, a master of composition. He would study the classics and his setups in detail until he achieved the desired result. He then arranged them in the picture with attention to minute detail, suggesting rhythms, movement, space, color, and light.

Fig. 18. Giorgio Morandi. *Still Life*. 1916. The Museum of Modern Art, New York. Morandi, an Italian painter who died in 1964, painted still lifes throughout his lifetime, sometimes of the same objects. He would always arrange the objects in a surprisingly simple way— sometimes as a frieze, or one behind another, or alternating them, or, on occasion, using only one of them. His paintings are extremely sensitive, poetic, and very austere.

Value is key

We asked Martín Antón what his golden rule for teaching was, or expressed in more pedagogical terms, what the goal of his teaching philosophy was. Without hesitation, he answers: "value. Value is the most important thing. From the first week you use a paintbrush until you've been painting for two, five, or ten years, you have to determine value."

Determining value is the same as knowing how to see or how to observe and, therefore, knowing how to interpret. To determine value is to express the changes of light and the changes of color produced by the shadows, the reflections, the lights, and the various relationships between the objects. It determines the third dimension, expressing the volume and the depth. In effect, we let ourselves be guided by what we "know" is in the subject, for example, the handle of a dark blue vase, even when it blends into a shadow and is lost in the black background.

We "know" it is there and we paint it. Then suddenly an incongruous brushstroke appears that does not "fit" in the overall picture. It explains nothing and actually misleads. We have painted what we know to be there but not what we see. We only see the dark background into which the handle has disappeared.

Fig. 19. In this watercolor exercise by Francisco Javier Garrido, the problem of solving the volume of the objects and their relationship—shadows and location—is attempted by carrying the tones between white and black, light and dark. Value is the most important consideration.

Fig. 20. A much more colorist manner of solving the same problem. Campos has composed this finely painted watercolor, making the best use of watercolor's purest, cleanest qualities. The volume of the objects is achieved by the use of color, changing the tones, making them more neutral or more opaque.

But there are different ways of determining value, as there are different sensitivities. In these works by Martín Antón's students we shall see two of them.

In the first case, the balance of light and dark shadows has been attempted by means of *chiaroscuro*, a technique that creates an illusion of depth and space around the principal elements of the composition (fig. 19). The modeling is expressed by means of the successive breaking down of the color toward black or white—the shadows turn gray and the light areas become lighter and lighter. In the second case, the value has been determined by means of the color (fig. 20). The shadows and light are expressed by means of color. They are bluish, green or burnt, warm or cool shadows. It is the painting of a colorist.

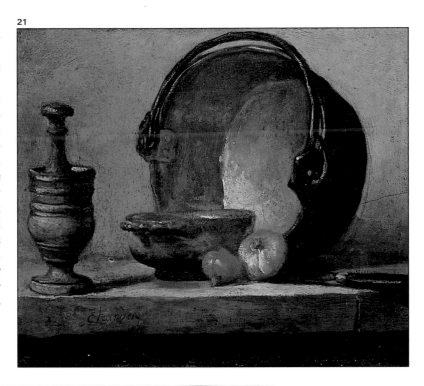

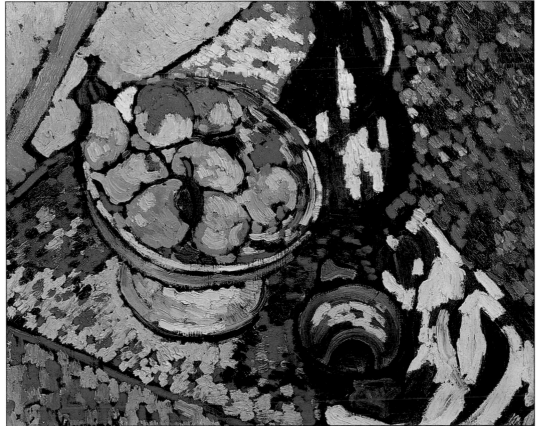

Fig. 21. Jean-Baptiste Siméon Chardin (1699–1779) *The Copper Pot*, Cognacq-Jay Museum, Paris. This is a good example of the change brought about by Chardin in still life painting. He returned to the reality of objects in daily use, and he painted them with beauty and affection; always delineating the light and shadows by means of chiaroscuro. As in the case of Francisco Zurbarán (1598–1664), the strong lighting and the sharp contrasts are the elements that give the objects volume.

Fig. 22. Maurice de Vlaminck (1876–1958). *Still Life with Flower Bowl*. Private collection, Paris. Vlaminck was one of the artists who, along with Henri Matisse (1869–1954), André Derain (1880–1954), and Van Gogh, explained the shape of the objects together with their volume, by means of flat brushstrokes of pure color. Each color possesses a given value: a pure yellow is lighter than a pure blue.

The relationships between colors

Before going any further, let us say that color is virtually nothing on its own; it acquires substance in relation to other colors. Colors, therefore, work as a group, by mutual dependence (a red next to a green does not seem the same as when it's placed next to a yellow, for example).

It is this mutual dependence that leads us to discuss different ways of working with color. Each painter, and even each of that painter's pictures, works on the basis of the different relationships between colors. These may be classified as either harmonious or contrasted colors.

The harmonious relationships are those established between colors of the same family (the range of yellows, oranges, and reds, the range of greens and blues, and so on) or between colors of the same value (light colors and dark colors).

The contrasting relationships arise between colors of a different range (the clearest example are the complementary colors: yellow/violet, red/green, blue/orange), colors of different luminosity (a light color together with a dark color), or colors with different temperatures (warm colors with cool colors).

We can say that, in general, a good painting contains all these relationships, although the balance is decided by the painter. A warm range, for example, might predominate, broken only at certain points by a cool color (for example, *The Sunflowers* by Van Gogh).

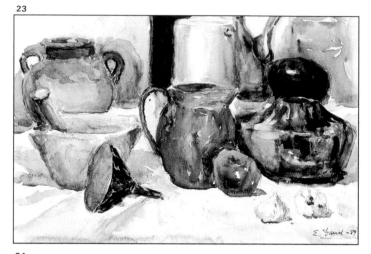

23

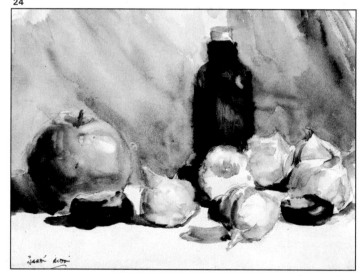

24

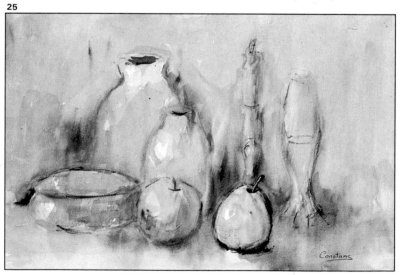

25

Fig. 23. In this pleasing watercolor, Emilio Daniel interrelates the elements of the still life mainly through the proximity of the colors: an earthy range of muted colors between ochre and green is used; there are only a few blues and some violet to hint at the shadows.

Fig. 24. This lovely little piece by Martín Antón constitutes a good example of watercolor painting considering color, texture, composition, and quality. The cool range colors in the background complement and intensify the warmth of the white shades in the foreground.

We are going to study two works in order to observe how the color relationships have been worked out. In the first picture (fig. 23), we can see the harmony achieved by painting with basically earthy colors, ochres and reds. Even the green is close to being an ochre or an earthy green. The mix of color is obtained by the inclusion of several bluish violet shades that take up much less space in the picture.

In figure 24, which is a good example of watercolor painting with a fresh and luminous touch, we can see the combination of warm and cool colors. It is wisely arranged in such a way that the cool blues and indigos of the background and the shadows (which occupy a large part of the picture's surface) make the warmth of the whites stand out in the foreground. These whites relate well to the warmth of the bottle and the apple.

26

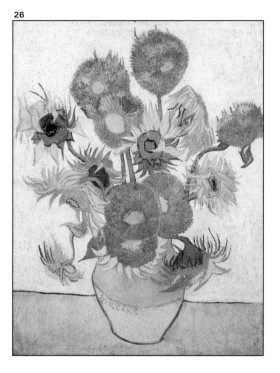

Fig. 26. Vincent van Gogh. *The Sunflowers*. Vincent van Gogh Foundation, National Museum, Vincent van Gogh, Amsterdam. Note that the brushstrokes are flat, all composed of yellows and oranges, with a blue stain only on one of the sunflowers and in the signature on the flower pot. The harmony in the yellow is brought out by the slightest suggestion of this complementary color.

27

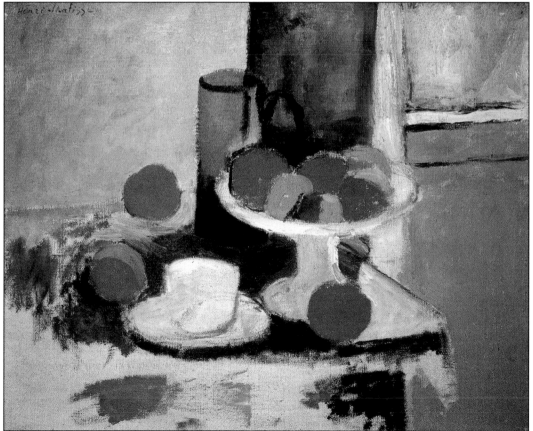

Fig. 25. Color used in an expressive way—for example, separating the yellow of the pear from the blues of the rest of the painting—can produce suggestive images such as this one. Why such an opposing relationship between yellow and blue? We would have to ask its painter, Constans.

Fig. 27. Henri Matisse. *Still Life with Oranges*. Gallery of Art, Washington University, St. Louis, Missouri. The impressionists and the pointillists, with small adjacent staining of complementary colors, managed to obtain grays. Matisse and ''les fauves'' went even further, as you can see in this painting, juxtaposing large stains of complementary colors and superimposing them in order to obtain a vibrant, expressive effect.

Watercolor: The synthesis and interpretation of forms through pictorial clarify

Fig. 28. Carmen Notario shows us a watercolor where the bunch of flowers appears to float against an undefined background. The flowers, that is, the stains that represent the flowers, end up merging with or crossing into the background.

Fig. 29. This exercise by Josefa Durán has been treated with very loose, wet brushstrokes. Here, the objects in the background end up merging with the subject as the colors are diluted.

28

29

Figs. 30 and 31. We will compare these two details from works by Campos (fig. 30) and by Maria Navarro Solves (fig. 31). The first one has great fluidity and makes the best use of the transparency of the medium. Three colors are used and the job is done. In the second one, the whites are reserved and certain brushstrokes over wet ones—merged— are mixed with other sharper ones.

When talking specifically about watercolor, we should address the real possibilities of this medium. Although you will see a wide range of examples of all these possibilities throughout this book, let us now put forward several ideas.

Watercolor painting has all the properties of water itself: it is fresh, gentle, sensual, and transparent. It allows a kind of effortless integration of color. Nevertheless, it is necessary to have a command of the technique and some knowledge on the correct amount of water to be added, and so on. In short, it is not as easy as it seems. You must help it. Do not worry too much and do not insist on it being unique.

Notice in these two works (figs. 28 and 29) how a relationship has been established between the subjects and the backgrounds. The subjects appear to be one with the backgrounds. The outlines of the objects fade away and blend in with the background without interruption.

Notice in these details (figs. 30 and 31) two ways of expressing volume and color. In the first (fig. 30), we see how the background has been stained with a warm color,

and then stained over with violet, leaving gaps to allow the background to breathe. The final touches are then made with some dark green strokes that make up lines and well-defined marks.

These three layers, rapidly superimposed, express both the shape and the volume of the spray and also the "air" moving be-

30

32

33

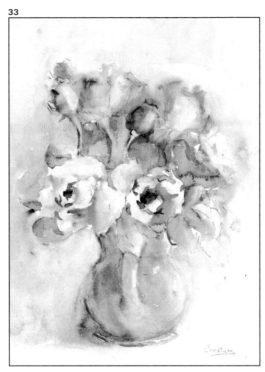

Fig. 32. A magnificent watercolor by Azor, another of Martín Antón's pupils. In this case, use is made of a great number of different methods: direct, dry brushstrokes, ''erasing'' or absorbing the color, reserving a white area (the topmost flower, for example), and spontaneous mixing (the background, green leaves).

Fig. 33. A very delicate watercolor by Constans, with gentle colors, mostly worked in wet colors. However, certain touches, such as the detailed and defined brushstrokes, give this painting volume and shape.

Fig. 34. Paul Cézanne. *Roses in a Green Flowerpot*. The Louvre, Paris. Cézanne's watercolors are extremely interesting in regard to their treatment, which has influenced every artistic movement of the twentieth century. He uses very small stains of colors that are well thought out and carefully chosen. Also, see how by reserving a large part of white paper he blends together the composition and introduces light.

tween the flowers. In the second (fig. 31), the definition is more obvious. There is a reserve of white paper, successive rubbings of the reddish flower, and some very fine, dark brushstrokes that define the shape and color of the flowers.

Now I should like to show you a watercolor done on a watery background (fig. 32).

The successive strokes can be seen—first the light ones and then the dark ones. They are superimposed and transparent. Let us notice the reserves and even some of the rubbing that has erased the color, leaving only a hint of color behind.

31

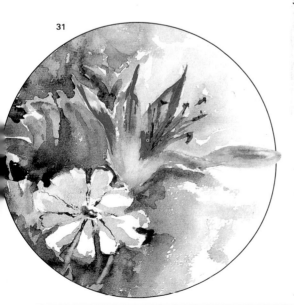

34

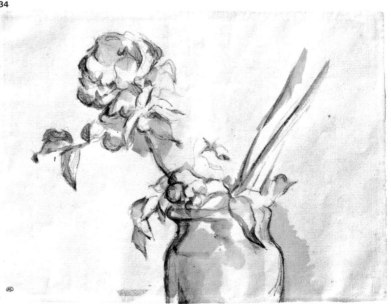

Painting and teaching

We are in the Catalan Association of Watercolor Painters, an established, traditional group, founded at the close of the nineteenth century, as we mentioned earlier in the book.

We are surrounded by students ready to paint still lifes, as this is the exercise that their teacher has given them. They are here to learn the technique of watercolor painting. The teacher is José Martín Antón, our special guest today, whose work we are going to follow. He will also paint a still life in watercolor for us.

The fact that Martín Antón paints among his students is nothing special for him—he often does so, painting between two and four watercolors a day, during the morning and afternoon classes. The association classroom, in a lively and well-lit room with "artistic atmosphere," is his studio. He can paint, then leave his own painting to move around the room looking at the students' work, correcting them, suggesting themes, and giving lessons.

We are going to illustrate his work step by step so that you can get to know his way of painting. Martín Antón is an expert in teaching this technique. For fifteen years he has been a teacher at this institution, which has approximately 130 students. In each class there is a maximum of fifteen students painting still lifes, as this is the most used technique for learning and practicing.

A curious aspect of this technique, shown here (fig. 37), is that the setup does not comprise a fixed number of objects. The still life is just a collection of flowers, pottery, bottles, fruit, and jugs, with its contents arranged in clusters, some on a higher or lower plane, and so on. This way the student can choose the portion he or she considers most suitable for his or her painting.

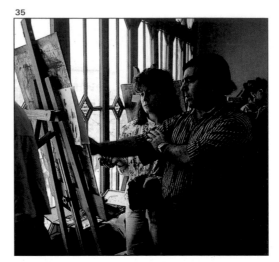

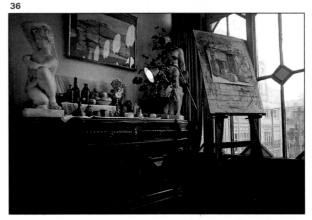

Figs. 35 and 36. José Martín Antón, our guest artist and teacher of the Watercolor Association, is correcting and commenting upon the work of a student in the same room where he will paint his watercolor. It is a gallery overlooking a courtyard. The still life has been placed near the window, bathed in a warm light, which is in contrast to the dark atmosphere of the classroom (fig. 36).

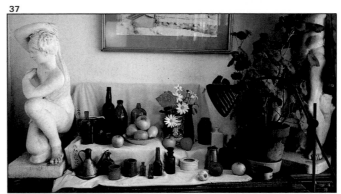

Fig. 37. This is the large still life that is composed of many varied objects, from a plaster reproduction to a flower pot. Both the teacher and the students will choose the section of the theme they intend to paint from this setup.

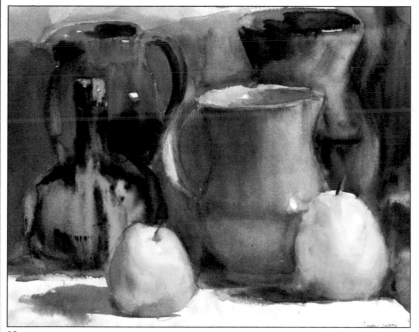

38

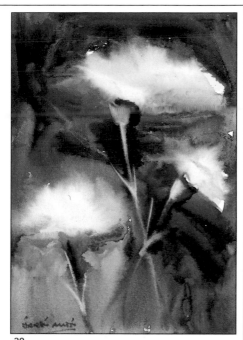

39

Figs. 38 to 40. Skill, experience, and talent combine to form the contents of Martín Antón's work. Antón specializes in still lifes, but also paints landscapes and other themes. You can see the decisiveness and the naturalness with which he works in all of his watercolor paintings. In the magnificent watercolor painting in figure 40, you can see how the work has been painted using a cool range of bluish colors that synthesizes the atmosphere and brings the elements of the watercolor together. You can also see the counterpoint, the warm patch of color in the fruit, that relates with the rest by means of contrast, providing movement, life, and meaning to the composition. A stain in the background, some reserves of white, and the precise hues that add shadow and light to the whole are sufficient to present the essence of the theme.

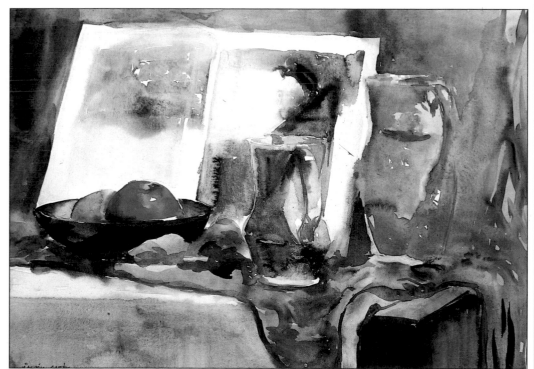

40

First stage: Drawing, gouache, materials

The session has begun. Professor Martín Antón and five pupils begin to paint the same portion of the setup (fig. 41) with a lead pencil and medium-quality paper. Martín Antón paints on Scholler Parole paper. The teacher and the students trace the shapes of the subject with a line drawing, without shadows. Antón's outline is agile and carefree. He's not too concerned with the exact contours of the objects. It is reminiscent, in this sense, of certain drawings by Aristide Maillol (1861–1944) or Matisse that had the same effect. But Antón then corrects the lines—the tracing—thinning them with the eraser (fig. 43).

We notice the boxes and palettes that the pupils have on the stools. The pupils paint with creamy colors or wet colors. We notice also the palette of a pupil that has only six colors: the three primaries (Prussian blue, carmine madder, and medium cadmium yellow), vermilion, emerald green, and ochre.

We ask the pupil, José María Ugalde, if the selection of colors is his or the teacher's. Ugalde and the other students tell us that Antón suggests the most suitable colors, but, as the course progresses, they choose their own range of colors. Ugalde points out that this reduced range of colors enables him to study the composition and general color mix better.

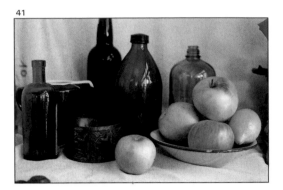
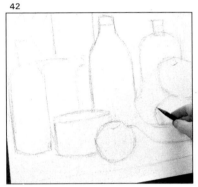
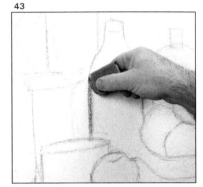

Figs. 41 to 43. Antón draws outlines of the objects that make up the composition he has ultimately chosen (fig. 41) with many nimble lines (fig. 42). After he is finished, he erases the unnecessary lines in order to preserve only the least formal expression of the drawing (fig. 43).

Fig. 44. This is the basic material with which Antón is going to work. A palette with the warm colors above—cadmium lemon yellow, cadmium orange, vermilion, and carmine madder (the other two carmines that appear will not be used)—and cool colors below—emerald green, sap green, cobalt blue, Prussian blue, indigo, and at the end, transparent rust red. The brush is a number 22 ox-hair paintbrush.

Another aspect of Antón's technique is he demands that his students paint with a number 22 brush—a thick brush "that corrects from the start," notes Antón. The classic mistake of the beginner, according to Antón, is to paint small details. Using a number 22 brush forces them, from the start, to loosen up and use wide brushstrokes.

Antón also uses a single, thick number 22 ox-hair brush. He has another brush ready, a flat, acrylic fiber brush with a beveled handle. He says, "I keep it more as an amulet, out of habit, not to use it. Now and then, I use it to absorb some color or to merge stains when I'm finishing a painting." He uses a piece of terry cloth to dry or clean the brush. In a large jar he has some tap water.

When the paper is very damp, Antón stops and waits for it to dry—but not entirely—only until the color does not run and the paper has recovered part of its capacity to absorb. "This moment can be recognized when the paper, still damp, begins to turn matte, to lose its shine," points out the artist.

Antón begins to paint. He is quick, extraordinarily nimble, working decisively on the damp surface.

Figs. 45 to 48. Antón paints with heavily diluted colors, after first applying an overall layer of paint in order to moisten the paper. He paints with local colors, defining the characteristic tone of each color, and shaping it with the brush strokes. He reserves some whites for the reflections in the glass and he freely stains the background (fig. 46) letting the color run and the water drip down. In figure 48, we can see the first stage of the watercolor: all the colors are gentle, the values have not yet been defined, and the patches of color blend into each other.

45

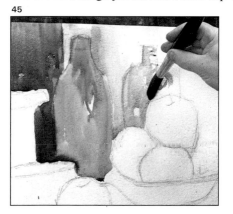

46

47

He begins to paint with a general gouache, which he does more to dampen the paper than to paint, although it is actually yellow ochre. I ask Antón:

"Does this first color condition the range of colors to be used in the painting?"

"Yes, it does," he answers. "Perhaps due to a Mediterranean concept of painting, I intend to paint with warm colors. And not only that," he goes on, "one must see the entire painting in a particular way. One cannot have a warm atmosphere and cool objects, nor vice versa. It is the lighting, the atmosphere that signals and defines the overall tone."

48

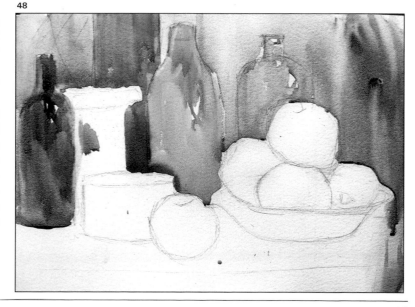

Second stage: Local color

Fig. 49. Antón continues to
apply paint, this time with
a very warm, muted color,
very close to the colors of
the bottle and the pots.
The wet brush makes the
tones pale, and neither the
dripping nor the accuracy
of the staining is important.
The main concern right
now is that the preparation
be suitable to be worked on
later.

Antón continues to paint and to stain freely, reserving white areas in order to give the picture a first layer of color. This is the "local color phase," he explains, "in other words, the color of the objects without shadows or light." This step is, for Antón, a transitory stage that will enable him to work on top of it with other layers of color. This is why the initial stain is very transparent and light, minimizing the local color and keeping it as light as possible, given the tone of the objects. Nevertheless, the blue bottle is quite dark because this is its true color. Notice also how the cool range is arranged in the background and on the objects that are far away from the center of interest—the green bottle further back and the blue one to the side—while the warm range brings the objects together—the apples, the brown bottle, the small pots in the middle—into a single, compact mass.

"The advantage of painting on wet paper," says Antón, "is that the color is made up on the paper itself, as if the paper were the palette. And then what we might

call the miracle of wet watercolor occurs, that mixture of tones and colors, of diluted stains, that lends quality to the watercolor painting." However, these stains and merges must be controlled in order to maintain and not destroy the shapes. Antón now gives us a demonstration: with the rag in his left hand, he alternates between additions and intensities, reinforcing tones and colors, but also absorbing—half drying the brush with the rag—opening up the whites and light areas.

He is now working on the entire surface, staining with broad brushstrokes and adjusting the tones and colors according to what he sees in the setup. The colors are made up on the paper, with the brush full of an almost pure-colored paint. See how Antón paints the apple on the table (fig. 51). He places the brushstroke of yellow and orange on the paper, dampens the brush, dilutes and rubs out these brushstrokes, mixes them in with the white of the paper, then blends and merges them, obtaining a very transparent intermediate tone. The advantage of

49

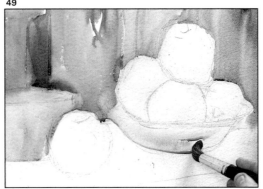

50

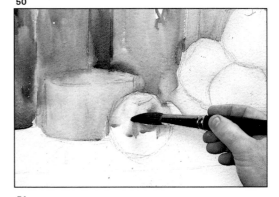

51

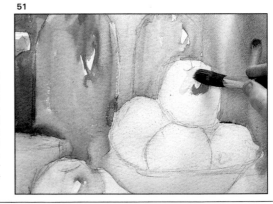

Fig. 50 and 51. In these two photographs, we can seen how Antón uses the white of the paper and the degree of moisture in order to create the colors and their different hues. This means that the paper acts as a palette. He applies different, very pure colors, and spreads them out after wetting the paintbrush. He then dilutes them on the paper itself in such a way that they combine to provide a tone full of different shades (fig. 50). Note the purity of the colors used to stain the apple (fig. 51), before carrying out the following operation of combining and diluting.

treating these first stains this way is that there are already many hues on the paper that, although they are scarcely different, enrich the color of the picture.

Another aspect of Antón's work at this stage of the picture (and we sense that he will continue to use this method throughout) is that he never cuts off the color. The stains do not belong to a single object. He continuously tries to merge them with a dry or wet brush—the yellow of the apple blending with the green of the bottle, the carmine of the background with the color of the jug, and the jug with the brown bottle and the small jar.

He now tells us that the picture is almost finished. Surprised, we ask him what he means. He explains, "now it's all wet, ready. It isn't dry nor hard. Now we have to reinforce it, but not insist too much." We imagine that these stains will need darkening or lightening, absorbing or adding, but not too much retouching. Now he will have to finish off the entire painting at the same time, and this means in watercolor painting that, in most cases, one has to begin and finish a section at a time, taking advantage of a particular moment and the dampness and the mix of colors. In this sense, we understand what Antón means when he says it is "almost finished."

Fig. 52. Antón goes over the outline of the apple again with the moist brush, creating a medium tone by combining the green of the bottle with the yellow of the fruit. He prevents the stains from being outlined, so that they are related to each other.

Fig. 53. He now absorbs some color from the box in order to create a reserve—a white—that he had not planned on. He does this with the brush half dry, after cleaning and squeezing it with the rag, so that it can absorb the moisture of the paint.

52

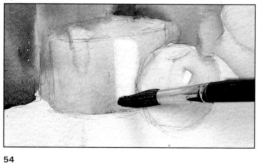

53

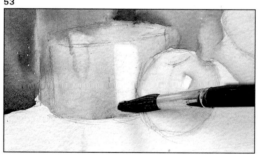

54

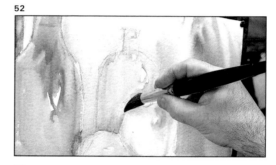

Fig. 54. At this stage, all the colors are still pale and undefined; this is the phase of local color, as Antón himself points out. Each object has its own color, although they have been reduced to a minimum. Nevertheless, we can already see the variety of hues within a single tone, and also how the range has been chosen—an essentially warm range of colors in order to suit the atmosphere, but contrasted with a cool background that begins to lend depth to the picture.

Third stage: Finishing off the picture

Antón now redraws and repaints over the background colors and shapes, applying a range of warm, muted colors. Notice the mixture of colors on the palette, made up mainly of complementary colors, that when painting with watercolor on white paper, produces a wide range of dirty, gray, and muted colors.

Antón moves from one area to another. As you can see, first he finishes off the dark shades in the background and the bottles with full brushstrokes. Then, for the green bottle, he creates the look of transparency in the glass by using water (a most suitable technique for achieving the effect of glass). He uses his brush to connect the green of the bottle with the yellow of the apples, giving volume to the fruit by applying light green, tending toward gray to the outline. Then he cleverly opposes contrasting colors, warm yellows and dark greens, to form the small jar. With the brush, the rag, and his experience, the paint begins to acquire a dense, "pasty" quality of color on color.

He uses strong dark colors between the pieces of fruit. He fills them with color—pure green, pure orange, pure yellow—that mixes together with precision, not minding the drips and the accidental mixing that stumps and brings together the colors. Antón's brush moves from the palette to the paper to the rag he holds in his left hand, again to the paper and from the paper to the rag, as if the latter provided the color.

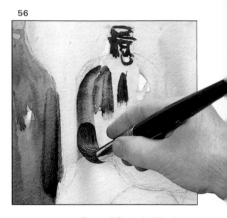

55

56

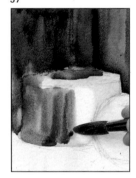

57

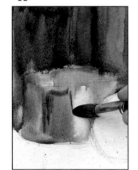

58

Figs. 55 and 56. Antón repaints the background with warmer tones and, with the same color and without raising the brush, he begins to work on the glass bottle to give it volume. The difference in tone between the background and the bottle comes from the previous layer of color. He then stains the green bottle with a strong sap green. He uses the same thick brush for both the broad and the fine brushstrokes.

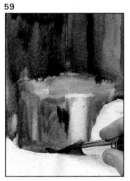

59

60

Fig. 61. This is the palette of muted colors that Antón is using now. It is, as you already know, a matter of mixing complementary colors in different proportions to obtain the desired effect.

61

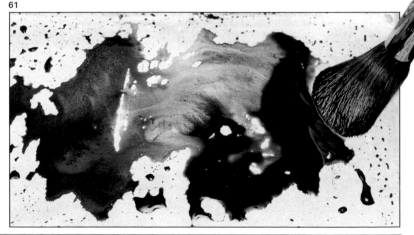

Figs. 57 to 60. Here is a short step-by-step look at the process of painting the decorated box. Antón stains with the brush full of water and a muted green color (a mixture of sap green and orange) with broad brushstrokes on the most heavily shadowed area (fig. 57), leaving reflections and reserves of background color. He cleans the brush, mixes red and green to get a dark brown, and applies small brushstrokes over this damp green, which blends into it without disappearing entirely (fig. 58). He then mixes again to create a dark, warm green and he applies small patches at key points, producing a hint of the shadow and the decoration at the same time (fig. 59). With the same color, he then applies transparent shadows to the inside of the box (fig. 60).

Figs. 62 to 64. Here is how the apple has been painted. He applies a pure color, cleans the brush, applies another pure color, cleans the brush, wets the brush and paints with the water, mixing the colors on the paper. The brushstrokes are quick, intense, and zigzagging. He then combines them with other, colorless brushstrokes, also zigzagging, and lending volume to the fruit.

"No, of course it doesn't," explains Antón, "the rag only contains moisture, but with that moisture and the ability to absorb part of the paint from the brush, the rag ultimately becomes a medium for painting."

But let us try to see how Antón paints. First he places the intense, almost strident color. Then he paints a piece of fruit with zigzag brushstrokes and wets and cleans the brush in the water in the bottle. He absorbs the excess water with the rag, diluting the color, and opens up the white of the reflection. He then returns to the color, the water, and the rag blending and mixing the color on the paper "palette." He returns to the water and to the rag with a series of instinctive, almost mechanical movements "that lead the hand and the mind," as Hauser would say, and reveal the artistry, allowing the artist to paint and concentrate only on interpreting, resolving, and creating art.

62

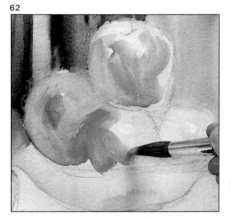

63

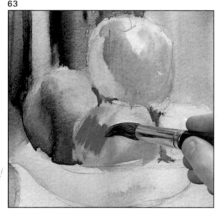

64

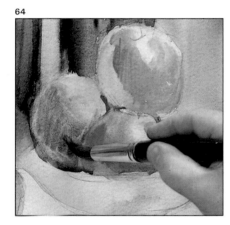

65

Fig. 65. This third stage shows the progress of the picture toward defining the volume, the light, and the shapes. The range of color is based on a mixture of muted color. The whole picture has been worked on—from the blue bottle, which now appears with subtle changes of hue, to the group of apples, which have acquired strength through the use of shadows and light. Do not overlook the color and the variety of shades, as can be seen in the apple in the foreground, or the brown bottle. The objects begin to acquire a certain position and to occupy a space that could be considered realistic.

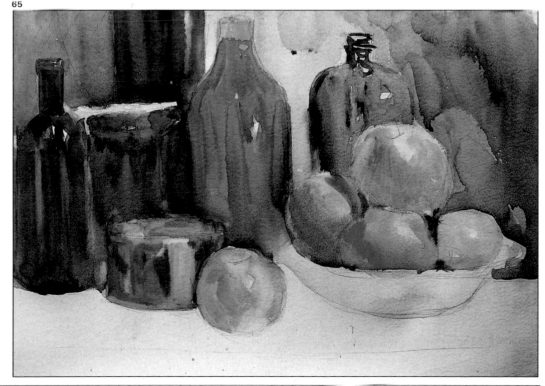

Fourth stage: Volume, shadows, and relationships

Antón alternates between the painting of his still life and the teaching of his class. He insists on the technique of painting more on wet paint than dry "when the gouache begins to dry, when it takes on that matte finish." He insists also on the practice of blending: blending close colors, not closing up the patches of color and not cutting back the objects. But, above all, he insists on the idea of value. In fact, he believes technique to be the "least" important thing, something that can be learned with some teaching and quite a lot of practice. On the other hand, determining value is something that always needs working on. One must learn constantly how to access value in order to support and build on the sensitivity that one has for color, for a given range, and for an undefined or specific treatment of watercolor. And this, of course, is what Antón has been doing since the beginning of the earlier stage.

The pupils, like their teacher, paint with a number 22 ox-hair brush. Everyone in the class works with creamy colors, and all of them clean and absorb the color or moisture with a rag.

Using masking fluid to reserve whites is unusual in Antón's classes. "It is not advisable, because the pupil misses the opportunity to learn to reserve in a natural way, cutting back with the brush or absorbing the color with the brush and, additionally, because there is always the risk of misusing this trick."

"Do you use absorbent paper, like paper towels?" I ask him. He answers quickly, "No. I am not against it, but I think terry cloth is more professional, more practical, more functional, and it is always at hand. It is also more economical."

Antón continues: "Now is the most entertaining moment; the moment of finishing." There are painters for whom the most interesting moment is when they begin, because of the freedom and freshness with which they can place the stains at the beginning of the picture. Yet for Antón, it is now when it is a matter of using several small brushstrokes.

Fig. 66. Several of Antón's pupils, whose work he corrects while he paints his own picture.

66

67

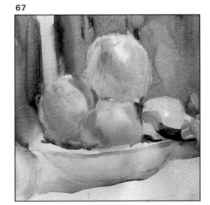

68

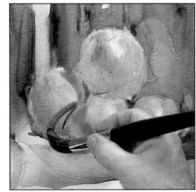

69

Figs. 67 to 69. Now he is working on the shadows. In the first case (fig. 67) he introduces a shadow on the apple with a warm muted color. In the second case (fig. 68), the shadow falling from one apple onto another is obtained with a grayer, more neutral color. Then he evaluates the fruit bowl as it is in the shadow (fig. 69). First he applies a long, full brushstroke to outline the bowl; then he dilutes this brushstroke, spreads out the color, which is now much softer, over the warm and pale background color.

He has defined the shapes, finished off the volume, and, above all, defined the relationship between the objects.

The shadows become darker, though they remain transparent. This is due, in part, to the technique of watercolor painting itself and to the clarity of the tablecloth, the fruit, and the plate, which cannot have too dark a shadow falling on them. See how the shadows are joined, blended, and related (figs. 67, 68, and 69). He does practically everything with the brush, from painting to erasing, absorbing excess paint, color, and drawing. In this phase, staining the foreground with a lot of moisture and leaving it diffuse but color contrasted, the picture is almost finished.

70

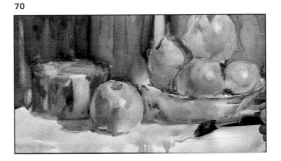

71

Figs. 70 to 72. Antón then stains the foreground. First with a warm, orange-yellow color that he lets run down to the lower edge of the paper; then with an absolutely complementary color, something between indigo and carmine, a dark violet color, that he applies over the moist yellow in the lower part of the painting. The foreground, therefore, stands out in contrast. The nearly finished painting can be seen in figure 72, with the volume defined and the colors well related. All the shadows cast by the objects have been put in place and the entire surface of the paper is painted.

72

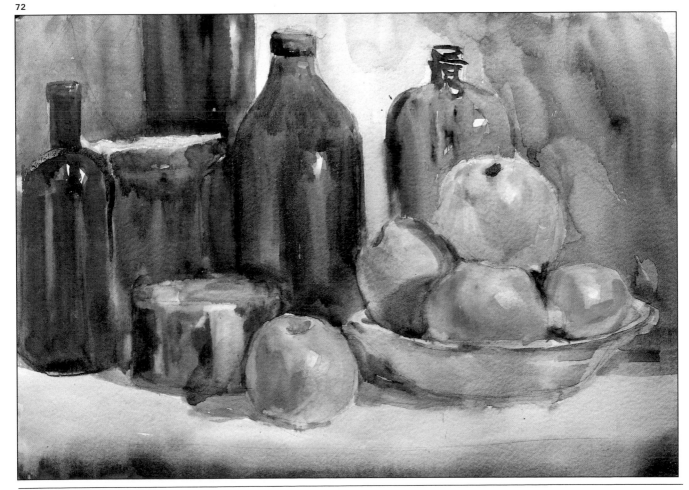

Fifth and final stage: Painting with water

Water, color, rag, water, color ... and diluting, blending, building. Suddenly, while he is painting the green bottle with wet color in a medium-tone gouache, he slides the brush toward the background, softening the profile of the bottle and blending it into the background.

Now he is working on the green apple in the foreground. He paints the reflection: he dampens and absorbs using the rounded brush, shaping it with the rag, transforming it with a filbert (or cat's-tongue) brush. It is important to note that the wet rag can shape the brush, pressing in one direction or another, in order to obtain a good tip.

He paints all the apples in the fruit bowl again, as if their volume had not been fully explained. First some bold, decided strokes, strident at first—pure emerald green that at first stands out from the rest of the picture too much. Then he joins these strokes with a brush full of red or yellow paint, and with a quick movement, after cleaning and wetting the brush in the water, he repaints using a series of nimble, nervous lines, over those colors.

As if by magic, the extremes disappear, the colors blend into the atmosphere, and the volume of the apples is finally resolved, with richer colors and hues.

After the final touches, he wets the now-clean brush again and puts water to the paper to soften the sharp edges. He goes over the outlines of the objects and of the shadows that seem too hard. He manages, by painting "without color," only with water, to create the language of a fine watercolor—heavily worked on, yet fresh, suggestive, and with atmosphere.

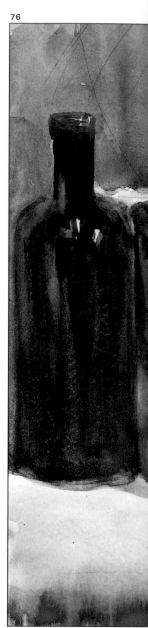

76

73

74

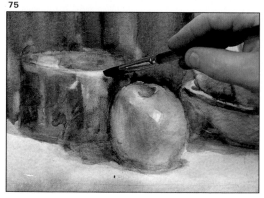

75

Fig. 73. Here Antón absorbs some color so as to paint the reflection of the tablecloth on the apple skin. He uses a half-dry brush, after having cleaned and dried it.

Fig. 74. Antón is constantly integrating the objects and joining together the patches of color. Now, while he is painting the bottle—or repainting it—he has drawn the brush toward the background in a long brushstroke that he will later water down. In this way, he avoids excessively outlining the silhouette of the bottle.

Fig. 75. With this system of absorbing color—first cleaning the brush, then squeezing it, and finally absorbing—Antón draws and paints the shine of the edge of the box located next to the green apple.

Fig. 76. This photograph shows the final result of Antón's watercolor. The overall effect of volume is based on the counter-balancing of the warm and cool colors, even though practically the entire range is of impure, muted colors.

If you remember how this picture started, you will realize that this combination was planned from the first patches of color applied. Let us focus our attention on this watercolor painting lesson, using this delicate, detailed, and dense work by Martín Antón. This is an agile piece of work, though profound and compact. Several areas have been left fresh and suggestive, as in the foreground and the shadows of the bowl and the apple in the center.

Other areas have been worked on in many layers, creating a sensation of volume and intensity of color and pictorial density, characteristic of a technique such as oil painting.

A painting with complementary colors

Dolors Raich is a painter who shares her artistic vocation with her family duties, although, as she has admitted, she is now devoting more and more of her time to painting.

This dedication, which has won her prizes and critical acclaim, immediately makes itself felt in her studio: here and there, in piles in every possible corner, we see the work of Dolors Raich.

As she herself says, "I devote all my available time to painting, not to tidying up." Here, in her "den," the floor and the walls are stained with paint, including the washbowl and the bath in which she sometimes "showers off" the works she finds unsatisfying.

Our guest artist prepares the setup for painting a still life in watercolor. As it is a gray day, she has decided to work with artificial light.

The objects that Raich places on a wooden drawer covered with a cloth are as delicate as the lighting: a seltzer bottle, a glass, and a glass bottle. Next to these she places a bunch of violet and yellow flowers with some lemons.

On the table where she will work, Raich has placed five sheets of 300 grade Arches paper, 14 inches × 20 inches (35 cm × 50 cm) and 20 inches × 27½ inches (50 × 70 cm).

She uses three brushes: two rounded marten-hair brushes, numbers 10 and 11, and one flat bristle brush, number 18 (a rather unusual choice for watercolor painting). She works with three plastic containers filled with dirty water, which enables her to paint and draw with three different tones (fig. 79).

For drying and absorbing the color, she uses a roll of absorbent paper towels.

Last, we can see next to the artist, the palette box with the Winsor & Newton colors she has always used. The variety of colors is made up of cadmium yellow or lemon yellow, cadmium orange, and pink sienna (in tablets) and dark yellow or gamboge, viridian, scarlet red, carmine madder, emerald green, cobalt blue, mauve, and black (in tubes).

A number 2 graphite pencil rounds off the list of supplies needed to begin.

Fig. 77. Dolors Raich is pictured here working in her studio. She stands while she paints, with the paper placed on a wooden board that rests on the easel and the drawer, forming a table. This room of barely 63 square feet (6 or 7 square meters) has the telltale signs of constant work—paint stains all over the walls and the floor. This is because Raich paints every day, "preferably in the morning," she says, "when the light that enters the studio acquires that pinkish quality I like so much."

Fig. 78. Raich has placed the different elements that make up the still life on the floor and drawer covered with a cloth. By doing this, she obtains an unusual overhead view.
The soft lighting, with scarcely a contrast, has been achieved with several spotlights that do not shine directly onto the objects but reflect off the wall.

Fig. 79. Raich has placed all the necessary materials on the table. In the foreground are the watercolor paints, the brushes, and the paper. Behind them are the containers of water and the paper towels.

The work of Dolors Raich

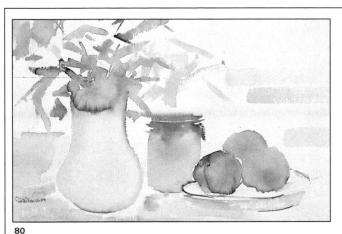

80

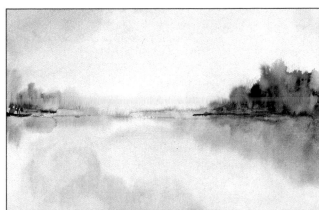

81

82

83

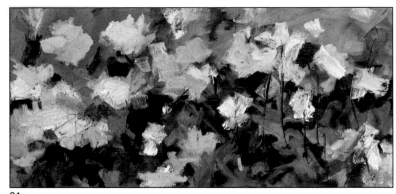

84

Figs. 80 to 84. Here are some examples of Raich's paintings. She defines herself as a restless painter of varied interests. This quality has led her to experiment with different techniques and materials. We should not be surprised, therefore, if we find everything from still lifes and landscapes in watercolor or oils (figs. 80 and 81), to themes painted with acrylics or combined techniques. These techniques, which sometimes include cement or latex, provide her with the qualities that reinforce the abstract and expressive individual tendencies of her painting. Nevertheless, in these works, such as figures 82 and 84, she always maintains a reference to reality—flowers, plants—that in no way thwarts Raich's firm aim ''to make painting an exercise in freedom.''

Learning from your mistakes

Fig. 85. Raich begins this first study by directly staining the paper. We could say that she draws and paints at the same time. With the flat bristle brush she extends the greenish gouache that forms the body of the seltzer bottle. Raich controls the degree of moisture in the staining to obtain the differences of tone that suggest the volume and transparency of the seltzer bottle.

Raich bases her method of work on speed. This allows her to paint several consecutive watercolor pictures in a single session, gradually getting into the theme. Raich is a painter who does not forget her mistakes and defects; it is from these that she learns the most.

Without drawing first, she begins to paint her watercolor: the seltzer bottle and the glass is her first subject. With a bold brushstroke with the flat brush, she paints the transparent body of the bottle with its greenish tone, letting the patch of color grow and become diffused (fig. 85). With the same

brush, taking up a little sienna, she sketches the head of the seltzer bottle and immediately fills in the detail of the nozzle and handle with the rounded brush using red and orange.

With barely three free lines, she draws the glass. She immediately finds it slightly out of proportion, so she flattens it to try and correct it. This direct manner of silhouetting objects—refreshing but risky—is one example of the "bravery" with which Raich paints.

Raich continues to finish off the glass with the flat brush full of very transparent, diluted orange. She reinforces the volume of the seltzer bottle by outlining its shape with a dark line. To the right of the bottle she draws the horizontal line that separates the background planes (fig. 86). Then, with a round brush, she spreads and mixes the different tones of the cloth—cooler to the right and warmer to the left.

Taking up the flat brush again, she adds a gouache of vertical and horizontal stains to the background in very transparent tones that let the white of the paper breathe through. These brushstrokes outline the objects. This is how they are built up, not only with the color that fills them, but with the outline of the background color.

Finally, Raich uses the pencil to add the decisive, irregular lines to the watercolor. With this surprising and individual touch, she has made up for the upper left-hand area that was rather empty, and has marked out the shadows of the seltzer bottle and the glass. "This type of drawing is something I have been criticized for," she explains, "but I find it necessary."

Raich feels that this first work (fig. 87) has too simple an approach and a certain weakness of color, so she leaves it under the table and gets ready to paint another.

85

86

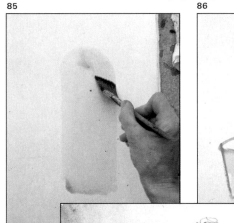

87

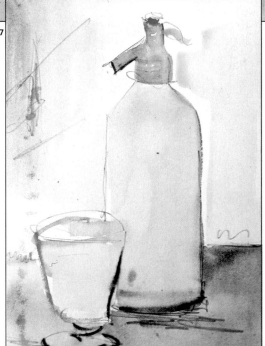

Fig. 86. Having painted the seltzer bottle and the glass, Raich now paints the background. She starts at the right by mixing a dark base tone with another reddish one. She always makes full use of the potential of this wet technique.

Fig. 87. This is the first finished watercolor. This simple still life has an obvious defect in the drawing of the glass—a too-short stem. This is one of the problems that can arise if a prior drawing is not made, but Raich accepts this as one of the facets of the way she works.

This is a session where the feeling of freedom that Raich considers so important for painting is predominant. She now chooses the bunch of flowers and the lemons as a setup. She also feels it better to change the light, so she does. She places the still life before the translucent glass of the window, which is on the floor level. The objects thus gain a certain degree of backlighting that enhances the subject.

On a larger-sized piece of paper, she begins by entering the flower vase, painting a fairly watered-down grayish stain that she extends with the flat brush. Raich has started to stain the paper with irregular, shapeless brushstrokes that announce a marvelous exercise in drawing and painting (fig. 88). It is undoubtedly themes such as this one that Raich finds ideal for her spontaneity: green, violet, and orange make up a luminous fan of flowers, leaves, and branches.

Raich now paints the lemons. Starting from two orangy patches, she, in a lesson on experience, brings out the lemons. She spreads the color, painting and drawing at the same time. She outlines the shapes with a finer brush and emphasizes the volume and creates light areas by absorbing some paint with a paper towel.

For Raich, who is now totally concentrating, it is usual to "go over time." She is constantly focused on the subject and the palette where she impulsively searches for the colors, changing brushes over and over.

As before, she finishes with the background—the floor and the wall—harmonizing them within a warm tone. And also, as before, she sketches loosely on the watercolor (fig. 90). "As in Giacometti's drawings," she says, "searching, always searching," Although Raich rarely signs her work, because for her the important thing is the work itself, these graphite lines are, without a doubt, her signature.

Raich stops for a break. She lights a cigarette and looks at the last watercolor (fig. 90). Although she finds it more satisfactory, she will attempt another to incorporate the first subject—the seltzer bottle and the glass, with their glass quality—that will add an interesting contrast to the flower and lemon theme.

Fig. 89. Before considering this sketch finished, Raich, using a very personal touch, draws several pencil lines on the watercolor. They are nervous, rather compulsive lines that, although they may appear to be decorative, are anything but gratuitous. These lines give life to the whole of the watercolor and consolidate the final version.

Fig. 90. In these prior studies, Raich tests different ways of working out the composition, the drawing, and the light. This may cause her to make mistakes, but it is in this way that you learn the most. In this case, the watercolor seems much better than the previous one, due to its more varied and rich tonality. Nevertheless, Raich wants to paint another one.

88

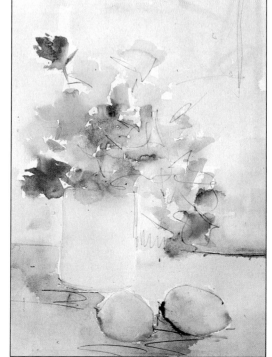

90

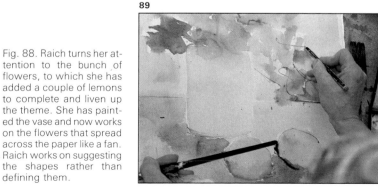

89

Fig. 88. Raich turns her attention to the bunch of flowers, to which she has added a couple of lemons to complete and liven up the theme. She has painted the vase and now works on the flowers that spread across the paper like a fan. Raich works on suggesting the shapes rather than defining them.

The definitive version

91

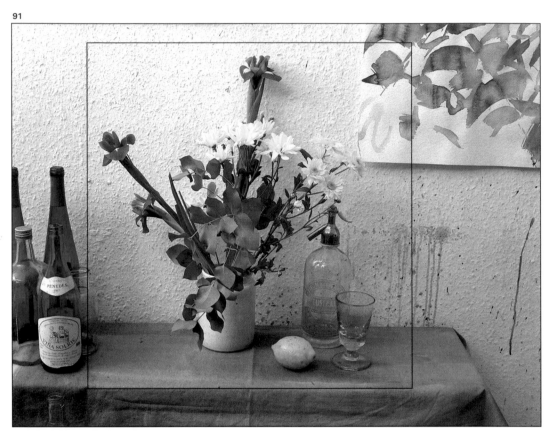

Fig. 91. This will be the theme of the definitive still life in watercolor. Raich has decided to combine the two sketches, placing the bunch of flowers, the lemon, the seltzer bottle, and the glass on the drawer. In this kind of zigzag of objects, the cool qualities of the glass objects and the warmer, more striking coloring of the flowers and the lemon come together. The same contrast appears in the cloth and the wall. Raich has decided to keep the indirect lighting, thus avoiding the contrast that results from strong lighting.

92

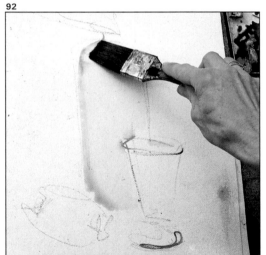

93

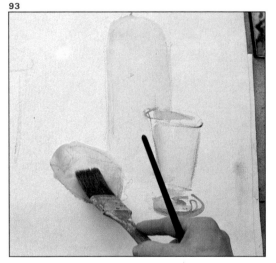

Fig. 92. Raich first paints the grouping on the right, formed by the seltzer bottle and the glass. This time she does not begin and finish each object separately, but creates a range of mainly warm colors from the beginning in order to harmonize them. The tones at this stage are fairly light so she can paint over them later with stronger, more intense tones.

Fig. 93. In order to maintain a relationship between the orangy areas of the seltzer bottle and the glass, Raich paints the lemon with the same tone. Starting with this shapeless stain, Raich, with the flat brush, has spread the color until the desired shape— Then, with a paper towel, she successfully creates the light that gives it volume.

Raich makes it clear that her state of mind before beginning this next watercolor is "to begin without any conditioning."

After observing the studies she has painted, she places the entire still life on the drawer (fig. 91). This time, perhaps so as not to repeat earlier mistakes, she arranges the composition beforehand. She pencils in the lines, suggesting the objects more than defining them.

As with the other watercolors, she begins with a very clear gouache, using wide brushstrokes in a dirty tone to represent the body of the seltzer bottle (fig. 92). Then, instead of emphasizing it, she freely draws the glass.

She paints the lemon using the same technique she used on the seltzer bottle (fig. 93). She then returns to the seltzer bottle. Here she details the head with the round brush, first with a warm tone as the base and then with dark brushstrokes that, when mixed, provide a muted earthy tone (fig. 94).

Raich continues to work on the glass. She extends a reddish color like that in the seltzer bottle handle (fig. 95). Then, as if to underscore the fact that she is finishing this part of her painting, she adds several black lines at the foot of the glass (fig. 96).

The seltzer bottler, the glass, and the lemon share a delicate tone that harmonizes them. This unity is reinforced by the pyramid composition. Raich is very clear on this point: "I try to make the picture into a world, with its own atmosphere." This is, therefore, a painting of sensations, where there is no direct relationship with nature. Reality is merely a point of reference that she discards if necessary. As she states: "I'm the one who controls the picture."

Fig. 94. After the color and the basic forms of the composition have been established, Raich begins to paint the details. First the seltzer bottle. With one of the round brushes, she outlines the head, letting the new, darker tone mix with the base tone, always maintaining control over the results.

Fig. 95. Raich continues to paint. She is now finishing the inside of the glass with a reddish tone that she extends with the brush. The same tone can be seen at the base of the seltzer bottle. Raich, by means of these details, tries to bring together the composition formed by the seltzer bottle, the lemon, and the glass.

Fig. 96. With two playful lines drawn at the base of the glass, Raich considers her work with this grouping of objects to be finished. Watercolor painting is a technique that does not allow one to retrace steps, and for this reason it is important to have a clear idea of what you want. In the case of Raich, this idea has gradually been defined. This means that each new watercolor is better than the previous one.

94

95

96
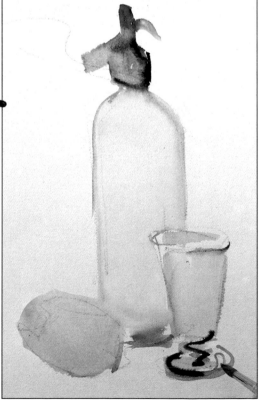

A cheerful painting

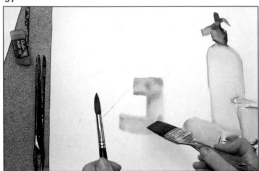

97

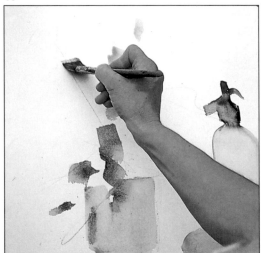

98

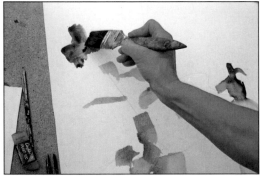

99

Raich prepares to paint the vase with the flat brush in one hand and some paper towel in the other hand. This subject, as we have seen, is the perfect vehicle for the "vivacity," "freedom," and "carefree nature" that Raich searches for in her painting.

She paints the vase with three plain patches of an earthy tone (fig. 97). She then adds a little blue, perfectly suggesting the porcelain. With the same brush now full of green, she applies several brushstrokes for the leaves (fig. 98).

She stops suddenly to change the water. She dislikes interrupting her work, "you can't lose your enthusiasm," she explains, but some very clean tones are needed for the flowers.

She paints the violet of the petals on the first flower with the bristle brush (fig. 99). Raich makes maximum use of this brush's potential—from the broad patch in its original shape, to the different variations, narrow, rounded, irregular, and so on. Conscious of this versatility, she paints more leaves (fig. 100).

Fig. 97. Raich begins to paint the vase. This time she has made a prior sketch that enables her to keep the objects in proportion.

Figs. 98 to 100. The flower theme is where Raich feels most at home. The stems, the leaves, and the petals of the flowers give her the opportunity to apply an entire repertoire of shapes and colors, as seen here, that are all painted with the same brush.

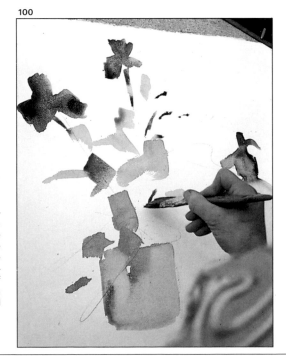

100

Figs. 101 and 102. Water-color painting is a technique formed by a mixture of chance and the knowledge resulting from experience. The painter must adapt the technique to his or her purpose, but he or she should also be able to notice and make the best use of the small details this medium allows for. It is a difficult balance to keep Here we can see two examples of this. Raich draws in several strokes with definite purpose.

Although she has gained confidence and decisiveness from the previous watercolors, the rate at which she works is the same.

Painting over wet watercolor—Raich's basic technique—requires her to pay a lot of attention to the patches of color on the paper. This is not a technique of definitive effects, but, because of its fluidity, it presents new and unexpected effects as the session moves on. It must be done quickly so as to use the desired degree of moisture. In the case of Raich, this immediacy is multiplied, adapting perfectly to the spirit that she searches for in her painting. Figures 101 and 102 provide two good examples of this.

Occasionally, it appears that Raich's brushes are fighting with the small tablets of paint (fig. 103). This point, which may seem minor, has a particular meaning for the painter: ''The brush picks up paint irregularly on one side more than the other,'' she says, ''so that when I apply it, I obtain very interesting effects.''

To finish the vase, she stresses the shadows and darkens the central part with a sienna and violet tone, leaving the white of the paper to breathe through (fig. 104).

102

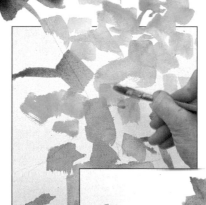

101

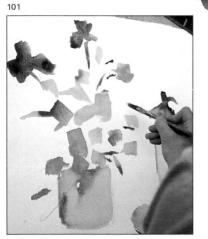

104

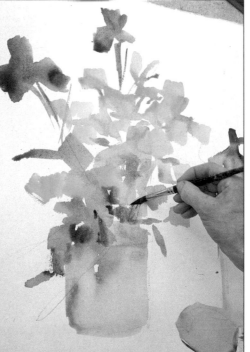

103

Fig. 103. Raich lets the colors mix on the paper, while also searching her palette for the tone she needs. When she wets the flat brush in the small color trays, the brush takes up an uneven amount of paint that enriches the brush-strokes.

Fig. 104. To finish off the vase, Raich covers the center of it with a dark, earthy tone. By covering up the white of the paper, she makes the surrounding tones appear more luminous.

The details and the finished work

The painting is nearly finished. Raich has painted all the elements of the still life, leaving the background until last. Her previous studies have given her a clear idea as to how to tackle this area.

In harmony with the pastel tendency of the theme, Raich separates the background into two planes—the cloth and the wall—with a broad brushstroke from left to right. She then uses violet tones for the cloth, spreading them over the entire lower part of the paper (figs. 105 and 106). Once again her unevenly loaded brush reveals its advantages by providing a greater variety of qualities.

She retraces, in black, the "earth line," which is now narrower and more striking, although she lets it spread a little over the wet paper so it loses its marked contrast (fig. 107).

To finish, she covers the background with a series of vertical and horizontal brushstrokes in violet. These brushstrokes form a crosshatching that consolidates the whole of the picture (fig. 108).

It seems that this time, Raich is more satisfied with the result, although she warns us that even when finished she still does not know if she will be satisfied with her work. "I have to let it cool off," she says. This is a simple work, of great delicacy and sensitivity (fig. 106).

As if to give her approval, Raich signs it in the lower right-hand corner. "I sign it," she says, "to finish the composition."

105

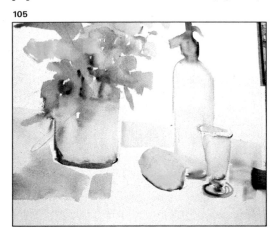

106

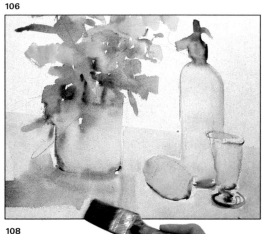

107

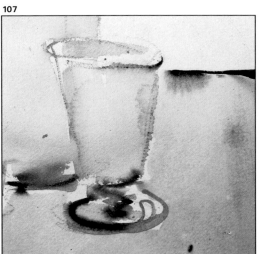

108

Figs. 105 and 106. Working within the dominant harmony of tones, Raich completes the watercolor by painting the lower part of the paper. To do this, she first draws a wide line that divides this part from the rest of the paper (fig. 105). She immediately covers the white with a very transparent violet tone, spreading it from right to left and then from left to right with the brush (fig. 106).

Fig. 107. In this detail we can clearly see some of the results of the brushstrokes applied onto a wet base. The lines and stains that were originally well defined become diffused and ill defined. This is how this "atmosphere" painting, so identified with watercolor, is achieved.

Fig. 108. Raich finishes this watercolor by painting the background. She does not entirely cover it, but leaves certain white areas, especially around the objects. They then appear outlined against the background. The color of the objects is defined in relation to those objects nearby.

109

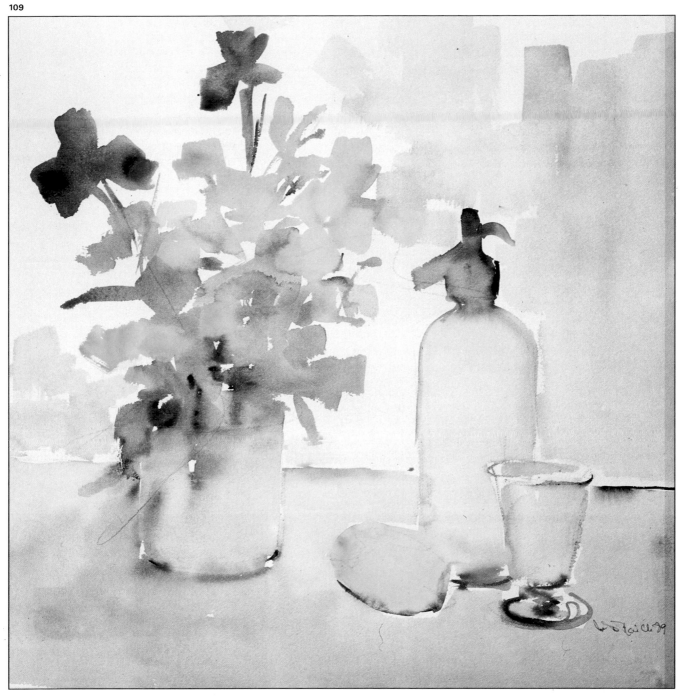

Fig. 109. This is the finished, definitive version. It is a simple painting, very subtle and delicate. The small details do not take away from the overall harmony of the work. This harmony is reinforced with a range of pastel tones that gently pass from light to dark, and from warm to cool. On this occasion, perhaps so as not to break up this harmony, Raich has preferred not to draw on it. She has, however, decided to sign it.

The painter, the studio, the material

Today, a hot and sunny June day, we are at the home studio of Amadeu Casals, which is located in a village near the sea. Casals, a painter of recognized prestige, does not fit into the classical lineage of figurative painting. He has his own personal style that is influenced by the work of Matisse and is directly linked to the refreshing colorism and graphism of French painter Raoul Dufy (1877–1953). However, Casals explains that he feels nearer to the postcubist period of Georges Braque (1882–1963), and that it is the "postcubist" work of this French painter, a colleague of Picasso's, that has motivated him and suggested new means of expression.

Casals, like many painters, began by making a thorough study of nature. He used watercolor and painted entirely in black with the result hardly distinguishable from a photograph. These watercolors took him 500 hours of work and yet he soon

110

began to search for "other things." Things such as different, poetic, free compositions, closer to modern photographic framing, but overflowing with lyricism.

Casals's very pleasant, well-lit studio has a small raised section that acts as a small gallery. In this room we can see those pictures that have been awarded prizes. As it happens, Casals has just won an important award: the Ynglada Guillot award for drawing. It was for an India ink and gouache drawing that is simple, austere, and almost abstract. The lower section of the studio, measuring about 83 square feet (30 square meters), is the actual work space.

Casals suggests that the text of this chapter on his work not be exactly a "step by step" of a particular work, as he works in a different way: Casals does not paint "definitive works," but rather many studies—or exercises—on a theme. He then chooses the most interesting; these are the

Figs. 110, 112, and 113. Amadeu Casals at home and in his studio. Casals has a large, luminous studio, designed with exquisite artistic taste that is practical at the same time. It has a high ceiling, large windows, an unexpected chimney, and an elevated section used as a gallery. In the middle of the space is a worktable. Casals explains work surrounded by some of his pictures, some framed and others still attached to the board with thumbtacks.

Fig. 111. Casals has put out a great deal of materials on his worktable, although he does not always use all of it. In this case, he is using the palette in the center with the tubes of color: lemon yellow, cadmium yellow, cadmium red, cobalt violet, phthalocyanine blue, ultramarine blue, cobalt blue, emerald green, cobalt, green, indigo, Paynes gray, and turquoise blue. Two jars of water and paintbrushes of every kind and thickness are also out and ready to use.

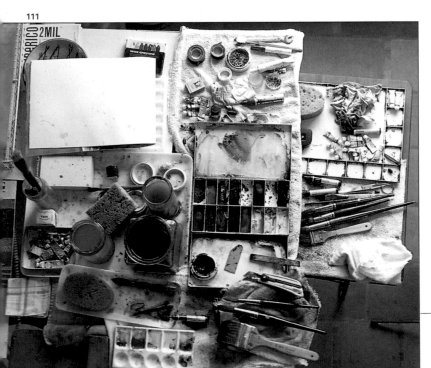

111

112

definitive works. We will reflect this process here. We will not write a "step by step," but will instead give you a graphic and written report covering the creation of one of these exercises. As a final work, we will present five watercolor paintings that are five studies on the same theme.

Casals uses a large quantity of materials, although not all at the same time, of course.

He is going to paint on Fabriano paper, 27½ inches × 39 ⅜ inches (70 cm × 100 cm), and puts it up on the board with twelve thumbtacks. The colors he is going to use are those seen in the palette box in the center of the photograph on the facing page (fig. 111). They are creamy colors, in tubes: lemon yellow, cadmium yellow, cadmium red, cobalt violet, phthalocyanine blue, ultramarine blue, cobalt blue, emerald green, cobalt green, indigo, Payne's gray, and turquoise blue. The brushes are wide, numbers 18 and 24, and he uses a number 30 knife.

Apart from these materials, you will be able to see how he uses other tools: a cutter, an India ink cartridge, a wooden strip, and so on.

The setup for the work (fig. 114) is a still life composed of quite original elements: a couple of umbrellas, a seltzer bottle, a jug, some fruit, and a piece of paper in the background. He uses artificial sidelighting and is now ready to paint one of his exercises.

113

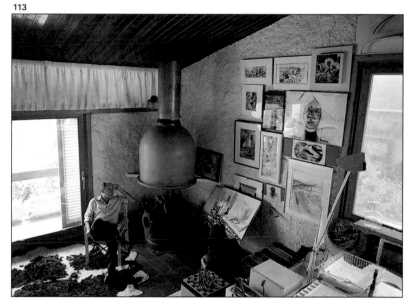

114

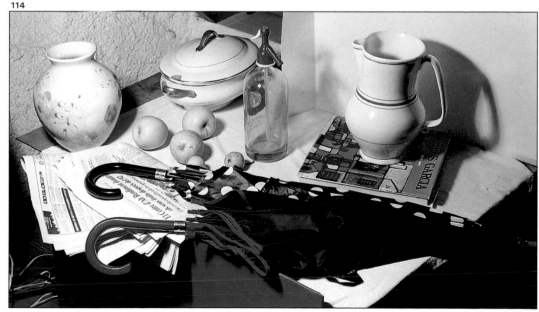

Fig. 114. This is the setup that Casals will use to paint the watercolor. Casals has painted other watercolors on the same theme, often changing the arrangement of the items. All of these watercolors, plus the one he will paint today, form part of an authentic, creative process, as Amadeu Casals understands it: it is a "step by step," but of different works. Note the folded vertical paper used as a background and the casual arrangement of the fruit. The lighting is from a strong white lamp on the side.

The work of Amadeu Casals

115

116

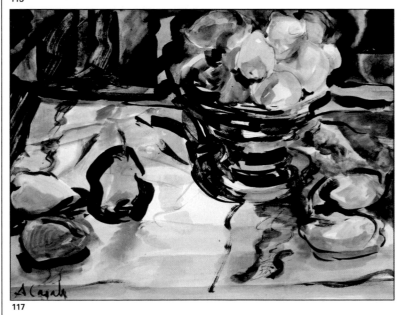

117

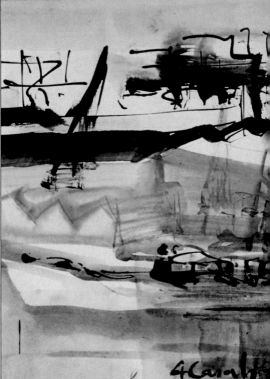

119

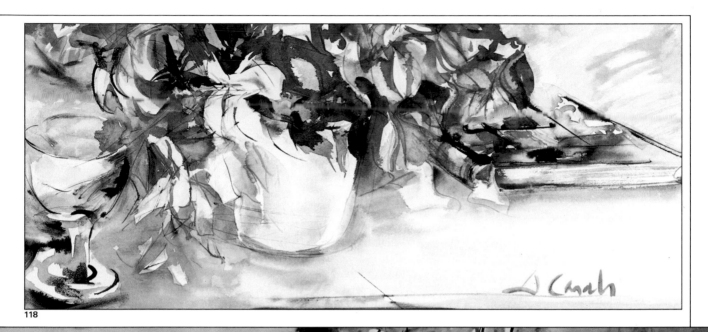

118

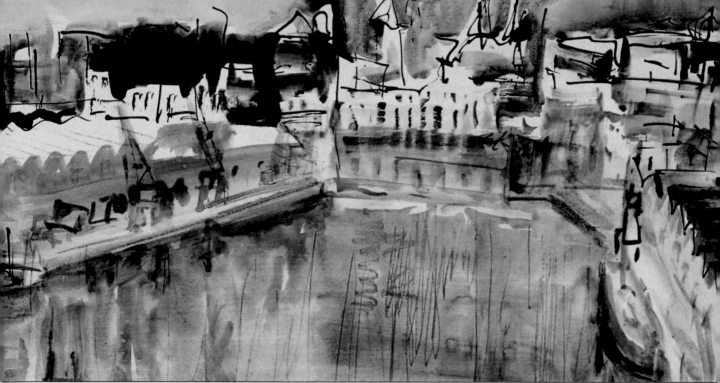

Figs. 115 to 119. Landscapes, still lifes, or any other types of themes are used as a pretext by Casals for creating his lyrical improvisations. Everything appears in a little-defined, poetic manner. The shapes are gathered by color and a pronounced drawing, composing a work full of suggestions, that is created as an abstract whole. The patches of color and the markings appear almost more strongly than the theme itself. Note the elements characteristic of Casals's work: surprising compositions without a horizon; studies in black; a subtle blend of wet colors; decided strokes of black; outlined objects; intense lines and planes of color; pictorial will over the will to represent.

The interpretation

We will now examine the painting process of one of these exercises—the still life in figure 114. This is so you can see Casals's techniques and observe his methods. Remember that he is not creating a "definitive work." Let us enjoy the magic of his brushstrokes, the free application of the paint, and the refreshing watercolor that these will produce. We must also learn new ways of working, as this is what counts.

After wetting the paper with a towel, Casals fills the brush with pure colors, one after the other: first yellow, then yellow and red; then he cleans the brush and takes up emerald green. He applies three large strokes of each color, hinting at the fruit and the seltzer bottle. He does not draw, but applies patches of color in the center of the paper.

"I want to achieve this by using color. So my approach is using color," says Casals. Using the blade of the cutter, he immediately opens up white areas (fig. 121). And then he uses a piece of cane, or absorbent wood, covered with indigo, which he rubs onto the paper (fig. 122).

Casals talks to us while he works: "These initial, green brushstrokes do not come to life as a seltzer bottle. I'm not going to fight against that—I'm simply going to paint something else. The same for these rubbed lines, which will be very useful to offset the paleness of the fruit."

120

121

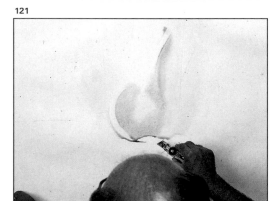

122

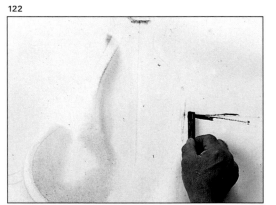

123

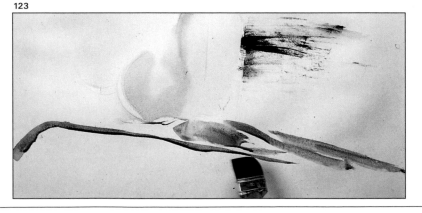

Fig. 120. Casals has begun by wetting the paper, and then painting the colors of the fruit and the seltzer bottle. Abstract patches of clean color are made with the brush.

Fig. 121. He uses the cutter to open up white areas, with the paint still wet.

Fig. 122. Now he is using a small strip of absorbent wood full of a dark color to paint the horizontal strokes to the right of the seltzer bottle.

Fig. 123. He suggests the shape of the umbrella, using the widest brush he has, with long strokes for the handle and broader ones for the cloth.

We can clearly see his idea: he does not limit himself to exactly copying the setup, but instead tries to create shapes and contrasts that, whether they are there or not, are suggested by his own view.

"In watercolor painting," says Casals, "this always has to be done. We must respond to what the patches of color suggest. I also believe that in watercolor painting, we have to keep the chromatism in mind, something that oil painters always do. You must know what you want, without restricting yourself to the subject."

Now, in the background, he paints lines and patches with the widest brush; he stains horizontally and then draws out the color vertically, from top to bottom. He reserves white areas around the fruit; they are not rounded whites, but angular ones. Casals

remarks that fruit can be rounded or not, or it may be surrounded by angular white areas. This freedom of interpretation is what cubism has taught us, and cubism offers many possibilities.

He has also painted the lower part of the picture with long brushstrokes suggesting the handle of the umbrella, and other wide, rounded ones representing the cloth. Notice that he has only suggested one umbrella.

Then, using the small piece of wood full of paint, he draws the shape of the neck of the seltzer bottle with gently rubbed lines; the seltzer bottle is no longer a seltzer bottle, and he stops to think. Let's take the opportunity to take a photograph of this stage of the picture.

Meanwhile, Casals remarks: "There's no need to hurry; people think that in watercolor painting you have to paint quickly. You don't. When you paint in the studio it is you who must control the work. You have to observe it, look at it. It's a question of living the work, thinking about it, placing yourself outside and within it. In this way you realize what you want: emphasize this or that, add intensity here or there. If you just paint and paint, simply copying what is there, well you're a camera."

124

Fig. 124. With the same brush, he stains the entire background, defining the location of the paper behind and creating a space by relating the different planes. First he horizontally applies a bluish color and then runs it down the paper to continue to stain the background.

Fig. 125. Casals, with these first patches of color, has already defined his work: "Always knowing where you are going, without staying too close to the subject." The fruit is cut back with some angular strokes. Only one umbrella appears and the jug does not exist. The seltzer bottle, in his own words, "has ceased to be a seltzer bottle, because the initial brushstroke suggests a different kind of object to me." The composition is very simple and centered. The planes of clear, defined colors prepare for the continuation.

125

The freedom of color

126

127

128

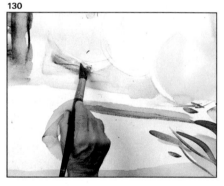

130

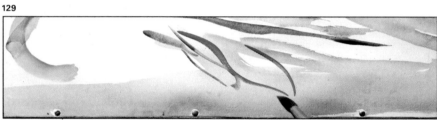

129

Casals continues. First, he needs some red on the umbrella handle, although he does not for the head of the supposed seltzer bottle. He paints the handle with the round brush (fig. 126) over the gray color he already had; "in watercolor painting, what has been painted must remain, you shouldn't try to erase it. Each brushstroke deserves to be seen, not extinguished," he remarks.

He is an artist in every sense; his work is open to interpretation and to his personal vision of the subject. Each element is related to another in the series of exercises; they make sense as a whole.

In the grayish blue gouache in the left-hand background, Casals applies a set of lines using the cutter placed on its edge to open whites and to draw (fig. 127). He is drawing the staves of a sheet of music! Why? "This theme has been greatly used in cubism—the collages—and due to its half-ordered, half-abstract look, it works very well as a background. In addition to this,

it creates more of a sensation of a straight piece of paper behind the objects; I like paper so much that besides painting on it, I also paint it."

In order to eliminate both the water and the paint from the brush, he uses a towel he has spread out on the table.

With the brush full of red, he paints some lines (fig. 129) like snakes over and between the gray patches of the umbrella, which help express the cloth better. He then places a shadow next to the apple, using the same brush and the same red color (fig. 130). He says that being able to paint a red shadow and an apple like paper is something he learned from cubism. This observation is a curious one; Casals must be referring to the intellectual attitude of "infinite possibilities of interpretation" provided by cubist painting. Nevertheless, we should point out that this arbitrary use of color was used by Matisse and "les fauvés."

Fig. 126. He applies a red brushstroke with the round brush to redraw the handle of the umbrella, without bothering that the original color underneath is still showing.

Fig. 127. With the cutter, he makes some markings on the background color, which suggest a music score.

Fig. 128. He stains the picture in dark green, with the edge of the brush, and then, with the brush flat on the left of the paper, creates a sensation of space behind the paper.

Figs. 129 and 130. Again, he paints the cloth of the umbrella red. More than stains, these are rich lines that make us imagine the curves of the umbrella. Then he starts on the background: a kind of shadow of a new apple has appeared on the music score.

Fig. 133. With the same piece of wood he paints a straight, vertical line that separates the seltzer bottle from the background.

Fig. 134. Casals has stopped to think at this stage in the evolution of the picture. We take the opportunity to photograph it and to observe the flowing quality of the staining and the free use of color.

In this work by Casals, as in the fauvist works, the color is free from the restrictions of the real object; it appears freely in any patch of color. Now it is a vibrant yellow over a wet gray background. These patches are outlined in some cases, and in others blend together. The still life is alive and constantly changing. The colors change, defining the objects, and shadows appear.

Casals continues producing markings that draw the objects, in and out of the patches in an instinctive, direct way. They are linear markings—sometimes broad, other times narrow—that perhaps point to another interpretation of the objects (figs. 131, 132, and 133). The small wooden strip that he uses to draw these lines is used frequently in his work. On one occasion, the artist was painting outdoors when a passerby, interested in the object that Casals was using to paint, inquired where he bought this tool. Casals replied: "No, no, this is a piece of wood!" And the passerby, who looked as if he had taken it as a bad joke, replied, "I sometimes paint with a broom, too."

Fig. 131. With the small piece of wood, he produces a wide, curved line that outlines the yellow apple.

Fig. 132. He then uses the same piece of wood, full of color, to produce this sharp line that defines the spokes and the cloth of the umbrella.

131

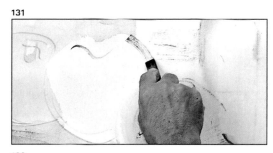

132

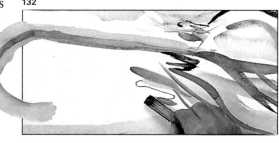

133

134

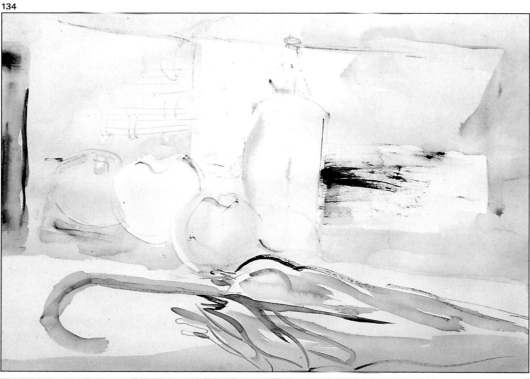

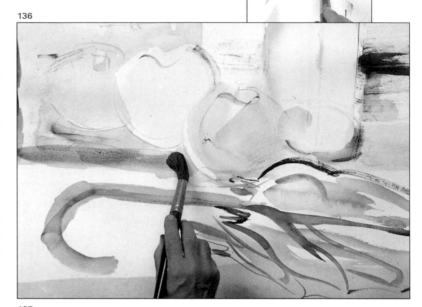

135

Shadows, markings, and color

Casals now decides that the seltzer bottle should be more important, and he paints the head with a dirty emerald green color, although in reality it is red (fig. 135). This is in accordance with his decision to interpret reality—relate the colors in the picture—and not adjust it to conform to the subject.

Then, he stains the shadowy area of the apples with a mixture of blue and indigo, and runs this color inside the yellow apple, outlining the color (figs. 136 and 137). He thinks he should dirty this yellow because it was "too pretty." He points out that he usually begins directly with very intense colors, although this time he hasn't.

The important things about Casals's work are the calligraphy, the diction, and the enormous variety of markings he uses, each in relation to the others, like questions and answers within a painting. He continues to add shadows: With an almost black brushstroke (Payne's gray plus violet), long, hard, and very wide, he creates the shadow of the umbrella, but it is more than a simple shadow (fig. 138).

136

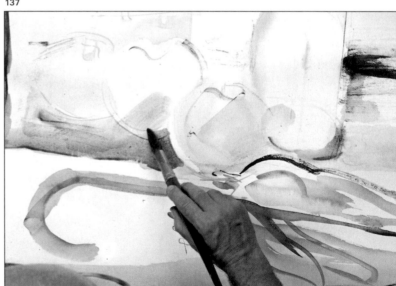

137

Fig. 135. In this photograph, the decision to change reality according to the artist's intentions can be seen. Casals paints the head of the seltzer bottle with green instead of red. (He comments, "red in this part of the picture doesn't suit me.")

Figs. 136 and 137. Casals applies stains with a long, horizontal brushstroke underneath the apples, as if to suggest a shadow, a separation. He then quickly enters the yellow of the apple, giving it more volume, integrating it into the atmosphere.

Fig. 138. With a large stroke of intense color, Casals reinforces the outline of the umbrella—a decisive touch in the foreground that up to now had only been hinted at.

138

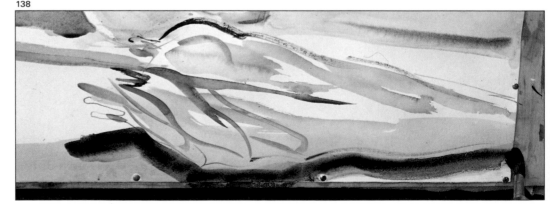

Fig. 139. Casals immediately defines the horizon (the end of the background plane) with another large stroke of pure red on the wet paper, which mixes with the grays.

Fig. 140. Casals puts some touches of violet onto the umbrella, in the center of the composition. These strokes cut through the previous ones.

Fig. 141. Now he is using an India ink cartridge (for technical pens), drawing very fine lines in a strong black.

Fig. 142. A vibrant color again appears in the center of interest of the theme—turquoise blue. Two small stains are enough to draw our attention.

He contrasts the markings; he stains the line, scratched with a wet mixture—a dark, rubbed stain brushing against another deep, velvety one. With great attention to detail, he has now decided to introduce more interest into some areas of the watercolor. He uses color to do this. He makes a few small brushstrokes in pure violet, superimposed and mixed with those that were already present (fig. 140). He then uses a long red brushstroke on the wet paper to define a kind of horizon in the picture (fig. 139). Several very small brushstrokes in blue turquoise are also added to the umbrella (fig. 142). All of this creates a central area of vibrant color within the picture and, therefore, a center of interest.

On some occasions, he draws fine, black line with a cartridge of India ink, as you can see in figure 141. This device is used to load technical drawing pens.

He works with two jars of water—one for cleaning and the other used just to fill the brush. The reason he gives for this is that, on occasion, he needs water clean enough to obtain better transparency in the pure colors like yellow or emerald green, which he uses often. Talking of colors, he says that he likes yellows. Yellow is the first color in his palette to be used up. On the other hand, he always has plenty of red left.

Casals is now close to finishing this exercise. As you can see, he does not work in a systematic way, but adds colors and markings as the picture suggests them.

For this artist, the framing of a work is very important. He keeps this in mind when he exhibits in shows. He tells us that the fact of framing a watercolor with *passe-partout* is like a label: it classifies the work as a watercolor and separates it from the category of "a work of art." A work of art is not a "watercolor," an "oil painting" or a "pastel"; it is a work of art. Therefore, the framing is important because it may give less value to a watercolor than to an oil painting, the so-called "king of painting." "There's no 'king of painting,'" says Casals, "I paint in watercolor because it's difficult, because I meet obstacles. Contrary to what some people think, I like to come up against obstacles."

139
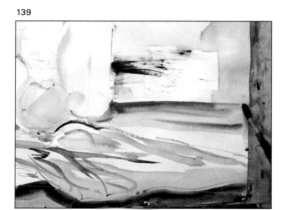

140

141
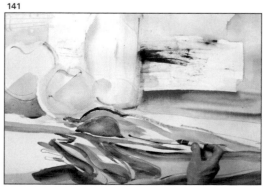

142

A picture is never finished

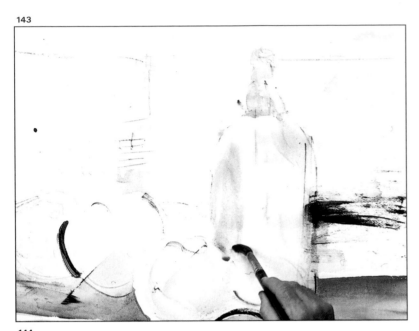

143

Now Casals is putting on the last touches, or perhaps they are not the last ones, because the artist tells us that he never "finishes" a picture. He does not sign it until he is convinced of its aesthetic validity—this may take months, and sometimes he is never convinced. Even while he is eating or resting, he looks at the works around him, framed or not (as his house looks like a museum of his pictures). He will suddenly get up and change or add something to a picture. Sometimes he asks the frame shop to take a watercolor out of its frame because he needs to paint, draw, or add something.

He paints with a clear gouache, half turquoise, half cobalt, over the musical markings; he fills them out, separating them from the fruit and the seltzer bottle.

144

Figs. 145 and 146. Casals uses the brush full of water to dilute the central stain of the picture, which improves the composition, and then absorbs the wet paint with a handkerchief. "I can't remove it entirely, because it offsets the marking situated next to the yellow apple," says the painter.

Fig. 143. The turquoise blue that Casals used for the umbrella is now used to enhance the seltzer bottle and the orange apple. The artist creates transparencies or shadows with the same color, depending on the relationship with the surrounding colors.

Fig. 144. And now, with several blues, Casals lightly stains the music score, heightening the contrast.

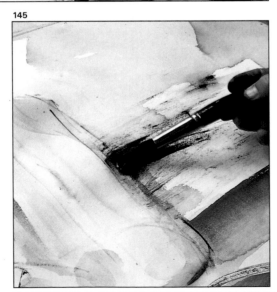

145

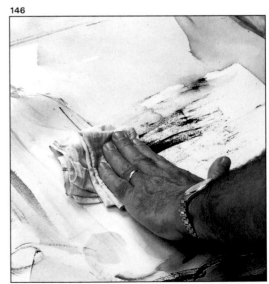

146

He also works on the seltzer bottle, giving more warmth to the glass. It appears that he has finished for today, and we take a photograph. But no. Right away he absorbs some of the color of the dark, abstract stain to the right of the seltzer bottle. He dampens the area with the brush and then absorbs it with a handkerchief (fig. 146). "An ordinary handkerchief. My wife will complain, certainly." But he does not absorb a lot, just a little, because he needs that dark area to offset the lines of the music score on the other side.

And now he leaves it, considering it finished—for the moment, at least.

You have followed the entire process. You realize that Casals has no qualms about making objects "disappear," or changing or destroying them, or even inventing them. The theme is a pretext, a starting point for

creating an imaginative watercolor painting. The work is more related to the artist's project than to the theme on which it is based. You can reflect upon the five exercises that appear on the next page.

We will let him comment on them himself, as the artist's words are always the best.

Fig. 147. This is the final version of the watercolor that Casals has painted today. This work is no more than a step in the creative process that the painter uses for this still life with umbrella. The final arrangement includes a clearer expression of the volume of the seltzer bottle and the red appears on the apple to the left, scratched with the cutter to open up a light area. Observe also the very broad reserve of white, which resolves the luminous contrasts of the picture. Casals has let himself be carried away by the suggestions of the stains on the paper more than by the theme itself. The concern for the composition, the marking, and the harmony of color produce this refreshing watercolor, characteristic of Casals.

147

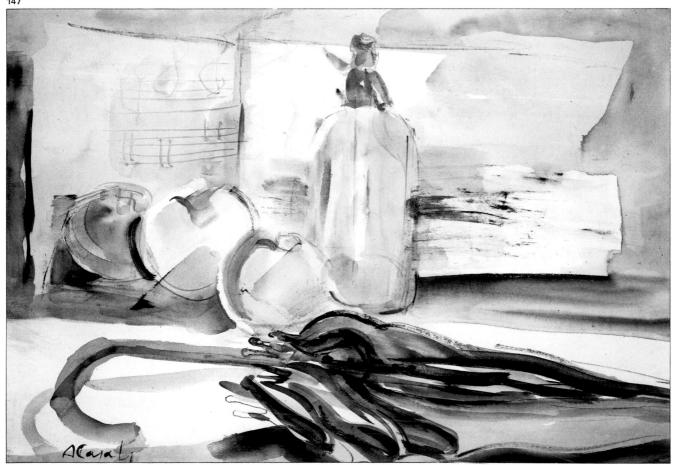

"Exercise by exercise, experience by experience"

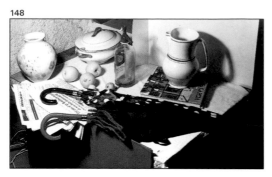

148

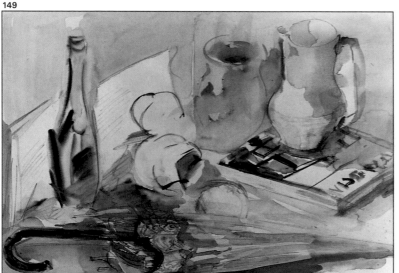

149

Fig. 148. We see again the still life that constitutes the setup for all these "exercises." This will allow you to compare the different interpretations of the theme.

"I would say that in this work that I have just painted (fig. 151), I find myself in the markings on either side of the seltzer bottler, and in the shapes and colors of the fruit, that are somewhat reminiscent of cubism. On the other hand, the seltzer bottle is not mine. In this other picture (fig. 150), it is the other way around; I have found what I was looking for and I don't want to retouch it, because this is how it should be. In that exercise (fig. 149), there is some interesting color work, but I haven't worked on the seltzer bottle or the spokes of the umbrella—I still haven't found them. And in that one, where the seltzer bottle is more defined (fig. 152), I have cut back the composition so as not to include the curves of the umbrella handles; I was more interested in the composition, which outlines the cloth and the jug. In this other exercise, with so little color (fig. 153), what I'm most interested in is the definition of the jug. So this in a way is a "step-by-step" process, but not toward a work, but a path of experimentation, of exercise.

"What I have just painted is an exercise, a result of the others. I am never definitively happy with anything, and I still see things that could be retouched, but not now, not in this picture; I would have to do another and open up another path, for example, working more on the jug."

Casals believes in the exercise, in experimentation, and not in the "definitive work." He therefore does not want the picture he has painted for us to be considered a "work of art" at all. He wishes to make it very clear that it is only a rough version, one of the many interpretations he paints of a theme. This cannot be called a "step by step," but rather, it should be called an "exercise by exercise," in such a way that each watercolor constitutes a "step" or "exercise" of a hypothetical definitive work. We say "hypothetical" because what Casals does is not painting until the end, but after studying, he chooses the watercolor that is most interesting or suggestive.

150

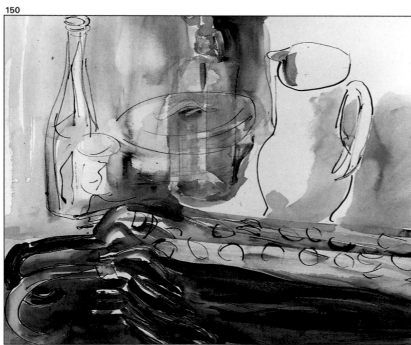

151

152

It is up to you to discover all the relationships that exist between each step of the overall work—between one watercolor and another. Which interests you most? Try to find out why one is more appealing than the other. It is a good exercise for judging and analyzing other people's works and your own. We believe that the comments that we have made throughout these pages will be of use to you when it comes to painting, and in addition to that, when it comes to assimilating this rich, vivid, restless, and ever-changing work by Amadeu Casals.

153

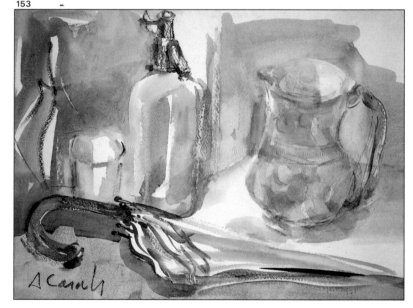

Figs. 149 to 153. Here we see five exercises, five "steps" of a single "work." For Amadeu Casals, the significant objects are the seltzer bottle and the umbrella; however, the seltzer bottle disappears in one of them, and in its place we find a wine bottle (fig. 149). The lovely white jug has also disappeared in one case (fig. 151). There-fore, it is the umbrellas that really define the theme, and force the artist to use a particular system of composition: the umbrella is always in the lower section, but is not always horizontal. In some cases, it is as if Casals were more concerned with the composition: For example, in figures 149 and 152, we can see that the lines of composition are clearer and intentionally more pronounced. In other cases, there is more desire to work on the color: figures 149 and 151, for example. In figure 153, the color has been reduced in such a way that only the red head and the red handle of the umbrella stand out against the overall blue color. In figure 150, the linear markings are superimposed over the freely placed patches of color, but they do not outline the objects. The expressive force of the two umbrellas in the foreground makes this perhaps the most characteristic watercolor painting by the artist.

Manel Plana, a painter of light

154

Manel Plana, born in 1949, is a young professional, yet unpretentious, artist. As he says himself, "success is only valid if it is backed up by work." He is a friendly, sociable artist, more than willing to explain his creative process. He tells us that at the beginning he was attracted to the world of advertising, but that he ultimately chose to paint because he felt more comfortable in the field of art, where he wasn't dependent on outside factors such as clients, and so on, and where he didn't have to work in a "tough," competitive business atmosphere.

His work has been exhibited on many occasions and he has won many varied awards especially for his watercolor paintings, although he also paints in oils. Among his awards was the first National Watercolor Prize 1980, in Barcelona. His paintings seem to have their own light; they are bright, irridescent pictures, almost always possessing an atmosphere of strong white light.

He prepares the theme for today's painting—a still life in watercolor. He lays out a neutral background (a linen cloth), and on the table, a white tablecloth. The objects on the tablecloth are very clean, mostly white. The fruit is added for warmth and several sprays of dried flowers are placed in the setup as a "pretext," explains Plana.

The theme, which is pulled together by the use of so much white, receives its powerful lighting from a lamp. As the light is reflected, transparent shadows appear between the objects, making them appear to vibrate, surrounded by a halo of light.

Fig. 154. This painter is Manel Plana, a man enamored of his work, who does not like to pose, but smiles, understandingly.

Fig. 155. This is the theme, composed of mostly white objects against a rough background, which Manel has carefully arranged.

Fig. 156. A palette box held fast to the worktable by clamps. In this photograph, notice the two sketches of the theme Plana is working on, one in pencil and the other in color.

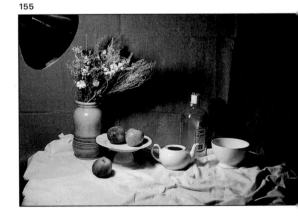

155

The Materials: Brushes that Plana uses: two squirrel-hair filbert brushes, numbers 4 and 8; a thick round squirrel-hair brush, number 10; and a bristle brush (a hard, worn oil brush) number 10. Tubes of creamy colors: cadmium yellow, cadmium orange, alizarin crimson, burnt sienna, ultramarine, and indigo. "This color," explains Plana, "is used for graying or darkening the tones." He also uses an apron, a rag and a sponge, and a palette box for mixing.

156

The work of Manel Plana

157

158

Figs. 157 to 159. Manel Plana has exhibited his work on many occasions and has been awarded important painting prizes. He asks me to clarify a couple of points, perhaps because he does not wish to be stereotyped. "That I work not only with watercolor, but also in oil. Although it is true that I have won the prizes for watercolors." And also, "I paint any kind of theme, whether it be a landscape, a still life, figures, and even animals." We have been lucky, and I say lucky because his work, as you can see, is magnificent. He paints landscapes, figures, and still lifes with the same ease. He takes maximum advantage of the transparency of watercolors to express the luminosity of his themes, as in the contrasted and expressive works from his recent trip to Morocco.

159

First stage: Drawing and quick staining

160

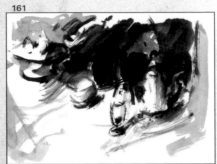
161

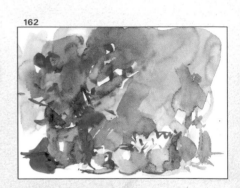
162

Plana shows us these watercolor sketches on the same theme. The position, the lighting, and the objects change somewhat in each one. They are studies of color, highly synthesized and poetic, with an abundance of reserves of white (figs. 160 to 162).

Plana begins to draw with the worn out oil brush! He mixes ultramarine and diluted magenta, and paints only the outline. He moves around a lot, approaching the painting and moving away. He appears to rehearse the movement of his arm as he holds the brush in the air. He has attached the paper with four thumbtacks, without wetting it previously, despite the fact that the paper is very large: 27½ inches × 39 inches (70 cm × 100 cm). This large size forces the artist to work bravely.

Lines and small patches are cut into and dragged over the paper with very little water. The composition contains the objects in the lower part of the paper. One object after another appears, rounded, but with vivid, loose lines. He marks the horizon of the drawing with an almost invisible line. "I do this for my own sake; it's very important, both for the composition and the arrangement of the colors."

Perhaps the first thing we have noticed about Plana is that he is a very friendly artist; he has been most willing to help us from the start, always explaining what he is going to do and how he works; not minding the questions we fire at him while he is trying to concentrate on his work.

He tells us that, despite the careful selection of the setup, he often changes it during the process, in accordance with what occurs on the paper. In his own words, "The important thing is the structure of the picture, what happens on the flat space of the paper or the canvas. What I see in reality, can be adjusted to the picture, what I paint."

He continues, "It is like a dialogue. You must listen to what the picture asks for. The mind can perceive it and answers automatically. Sometimes we do not know how to pay enough attention, and other times, it's the opposite, we hear too many things; then we cannot continue to paint." We shall be able to attend this "dialogue," to see how Plana carries it out.

Figs. 160 and 162. These sketches, as the one you saw in figure 156, are watercolor sketches painted from the same theme, with slight variations as to the position of the objects. However, Plana studies different compositions, changes in lighting, and varied treatments. He is interested in contrast, atmosphere, chromatic relationship, and so on.

Figs. 163 to 167. Plana draws with the bristle-hair brush, rubbing the paper and then painting over it with bright colors. He takes advantage of the spontaneous fusion of wet colors.

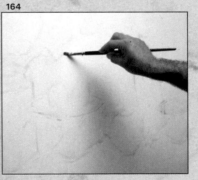
164

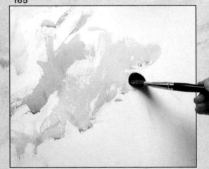
165

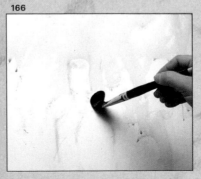
166

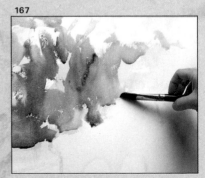
167

He works on the end of the spray with the number 8 filbert (cat's-tongue) brush, wetting it in yellow—with just a little orange—and lightening or darkening it with water. He mixes it directly on the paper with an ultramarine gouache, and covers the entire background. The brushstrokes are enormous, decisive, as if in response to the size of the paper, to quickly stain a large surface, instead of to detail specific shapes.

In the midst of this flurry of movement, he successively wets the brush in orange, green (a mixture of blue and yellow), sienna, and blue. He applies these intense colors, without mixing or dirtying them, to the area of the spray. We must mention that this has all been done very quickly, with the colors mixing and blending on the paper. The volume is there, though, in an almost intuitive manner. These colors, which have apparently been arranged "haphazardly," do not produce a "crazy" result; on the contrary, they create the spray that Plana wanted: "As a pretext, an excuse, a suggestion."

This "suggestion" is rich in hues and also in treatment: the patches and the brushstrokes are all different, some blend together, some remain outlined. Plana uses his hands or his finger to scratch off or remove paint, rubbing on the wet color—a lesson in experience.

Then he again chooses the worn-out bristle brush, wets it in indigo and ultramarine, and, as a brush of this kind cannot hold much water, he rubs it against the paper and draws several lines that define the vase. With the same brush and the same color, he now paints some twigs, or "lines that represent the spray," rubbing directly on the vivid background colors. What these brushstrokes define, above all, is the separation between each "twig" and "background," between "volume" and the "shadow that this volume projects." They are zigzagging, narrow brushstrokes.

As they have been rubbed against the paper, they let the points of color they cover breathe through. Due to the grain of the paper and the dryish brushstrokes, the pigment only penetrates in the raised parts, not in the small cracks of the paper itself.

In addition to this, the brush has moved in all directions because Plana has been changing the position of the handle, and, therefore, the bristles, with quick, lively movements.

Fig. 168. Plana uses the edge of his hand to bring together—blend—the still-wet colors. In this case, at the end of the spray, he wants to obtain a vaporous sensation.

Fig. 169. He now returns to the oil brush to hint at some shadows, small twigs, and the outline of the vase.

Fig. 170. Manel has worked especially on the spray, which he has suggestively resolved, in a vibrant, apparently unclear way. Look at that strong color and volume! Skill at synthesizing, a sensitive treatment, and the occasional reserve of white... and there you have the spray.

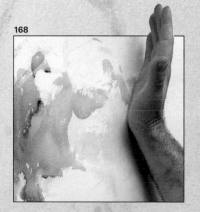

168

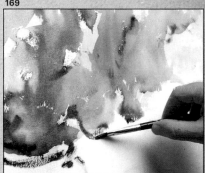

169

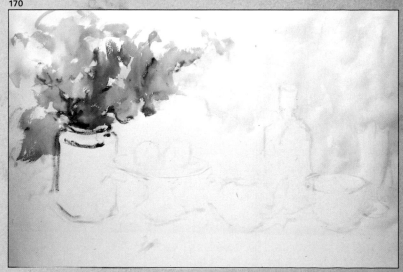

170

Second stage: Mixing on the paper

Plana paints the shadows in the background with the ultramarine, often mixed with other colors. On this occasion, he breaks the tone with burnt sienna. This is how he paints the shadow on the fruit plate and under the spray. He immediately cleans the brush, mixes some orange, yellow, and blue to obtain a green, and stains, with large round strokes, above the wet blue-broken violet.

stains the rest of the vase with transparent colors. Between the intense colors and the diluted colors he obtains the shape of the vase.

When everything has been painted, he takes the brush between his fingers, squeezes it, and absorbs paint with the brush moving continuously; half twisted, he obtains a shine, an open clear space on the vase.

At this moment, the vase has an intensi-

Fig. 171. With this color, basically made up of ultramarine mixed with a little burnt sienna, he has started to stain right under the spray. He then dilutes it to blend with the yellow of the background until he reaches the point where the patches of color in the background become confused with those of the tablecloth, outlining the objects and reserving the white of the paper.

Fig. 172. On top of the wet color, Manel Plana is now staining with small, round touches, in a very gray color. It makes·the shadows vibrate, as it is not even.

171

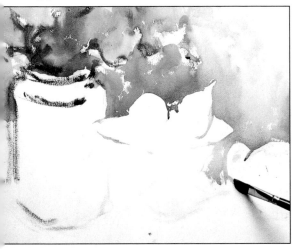

172

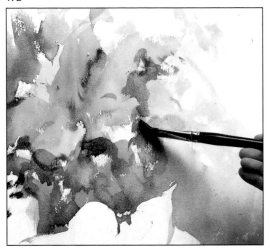

173

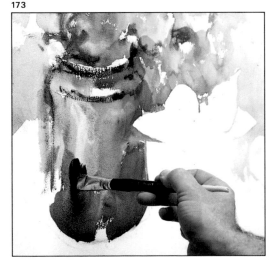

ty of color and a texture that approaches that found in oil painting. You must bear in mind, however, that a watercolor loses ten percent of its intensity when dry. This vase is a marvel of watercolor painting, abstract, synthetic, with drips and square brushstrokes that express the shadows and then fade into the background, toward the outer part of the vase.

Manel Plana says that the dialogue he has with the painting is very rapid because, in watercolor painting, one must respond quickly, almost intuitively, to what the patches of color on the paper evoke.

Perhaps due to this, a magenta color stain suddenly appears in the middle of the shadow of the central fruit plate.

He then outlines and stains with dark colors: blue and green over the dry spray, to obtain deeper shadows and stronger contrasts that express the volume.

Now he paints in pure ultramarine the darker part of the vase. He adds some water, mixes it with the carmine and sienna, and

Fig. 173. Plana works as quickly on the vase as he did with the spray. With three colors—ultramarine, carmine, and sienna together—he builds up this magnificent part of the painting. Note that it does not correspond exactly to the true color of the vase, but rather to the personal vision of Manel Plana.

174

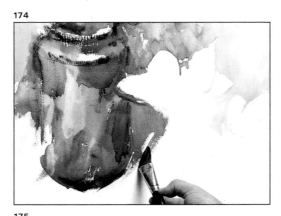

175

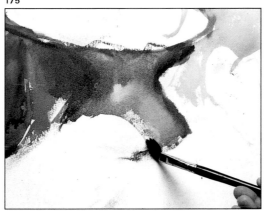

Fig. 174. He then reinforces the shadow of the vase and moves outside the boundaries with a continuous, curved brushstroke that outlines and reserves the white of the plate.

Fig. 175. Yellow appears at the base of the plate, in addition to the tones used for the vase. The semicircular reserve of white at the base of the fruit plate remains transparent and warm despite the blues, as it corresponds to the local color (white) of the fruit plate.

Fig. 176. If you compare this photograph with that of the setup (fig. 155), you will notice the variations that Plana introduces; variations that spring from his many studies of the theme, from his capacity for imagination, and, above all, from the attention that he pays to the picture. However, the luminous finish and the brightest reserve of white belong as much to his personal vision as to the set-up it is based on.

This shadow, as always, is blue. Rubbed down and outlined, it immediately mixes on the paper with the yellow, producing a gentle muted color.

Plana right away stains the base of the plate with an intense blue brushstroke that produces the shadow where it meets the white tablecloth. The fruit plate—with a large reserve of white in the lighted area—is now practically finished. The white of the paper, contrary to our expectations, does not break up the picture, but is perfectly integrated into the luminous contrasts that constitute the entire painting. With the same color, but more diluted, he directs the brush toward the background, and begins to stain the shadows in the nearest part of the background; that is, the back of the objects. At the same time, he moves into the handle of the teapot and the bowl, beginning to suggest the volume of these objects.

The watercolor is taking on marvelous qualities.

176

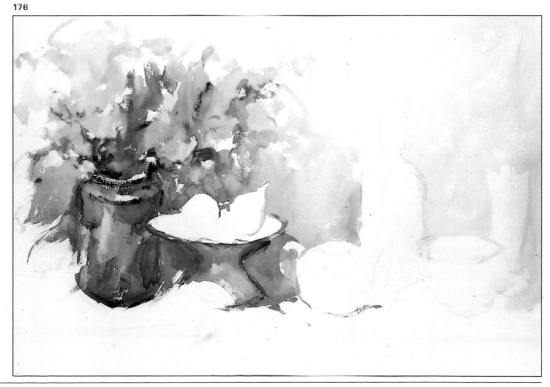

Third stage: Harmony in blue and yellow

Now, Plana stains the glass bottle with very warm, muted, transparent tones. He works here and there, overlaying the stains and leaving white chinks. The stains become integrated into one another.

Plana is not afraid to use his fingers. He often redoes the recent lines, outlining them, diffusing them, and softening them; for example, the lines of the brushstroke that silhouette the bottle.

The range that he is using is based on ultramarine and a mixture of this color and other colors, mainly madder, violet, and yellow, and in lesser quantity, burnt sienna. He obtains all kinds of values and hues—very transparent blues, some accidental mixtures, and pale gray tones with some diluted yellow that he suddenly adds to the previous color. In this way, a pale green is produced. This muted color adds a warm transparency to the background and expresses the whiteness of the porcelain, the light shadow of a white object, and the luminous reflection that characterizes it.

He paints the shadows in the interiors of the teapot and the bowl with a fairly diluted, slightly muted indigo. When the paint drips, he hurries to collect and absorb it with the squeezed-dry brush. He rarely lets it drip freely.

Plana returns to the background and continues to paint the shadow with the same tones, although now, in the mixture, sienna is the main color and so the effect is warmer, but also grayer. The brushstrokes are long and narrow, and broken, leaving white areas unpainted.

177

Fig. 177. With very soft colors—based on ultramarine and yellow—Plana finishes off the transparent glass bottle that is hardly separated from the background. He uses his finger to cut off a line that is too hard around the neck of the bottle.

Fig. 178. The bowl is now clearly expressed; the whites are white and the shadows fade into the background. On this occasion, Plana's finger defines and lengthens a brushstroke.

Figs. 179 and 180. Plana is staining the shadow inside the bowl, and the color, which is very watery, drips. There is a dark drop left that must be removed before it dries. He does so with the dry brush that absorbs the water to the desired degree.

178

179

180

181

Plana does not keep still. He quickly moves up to and away from the paper with his entire body. He looks at the picture and at the setup from every point of view, with gestures as if dancing, and then, quickly and spontaneously, he puts the brush on the paper.

When he stops, for a short while, he explains that he has worked on the same theme several times: he changes the position of the objects—situating the composition at the top, in the middle, or at the botton of the paper—and investigates the range of colors that most satisfy him for expressing the shining white areas. He knows the result of the mixtures and the paper. On this subject he explains, "The paper, as I always say, forces you to use different skills. You have to know the paper to make the maximum use of it and even so, it can sometimes give you an unpleasant surprise. Just yesterday this happened to me with this same type of paper; it was as if the gouaches had curdled, as if I had rubbed the painted paper with sandpaper. Very strange."

182

Figs. 181 to 183. Plana paints while standing up. In fact, he paints as far away as he can from the paper, because due to the size of the paper, he would lose his overview if he came too close.

Fig. 184. Plana lets a lot of white breathe through. In some areas, he has covered the paper with very transparent colors. Notice the shadows of the background: they are light, gently blending with the paper. The sharp outlines of several patches of color indicate to us, once more, where the area of light begins. Notice also how the objects come together, those on the right through gentle contrast, and those on the left through firmer colors.

184

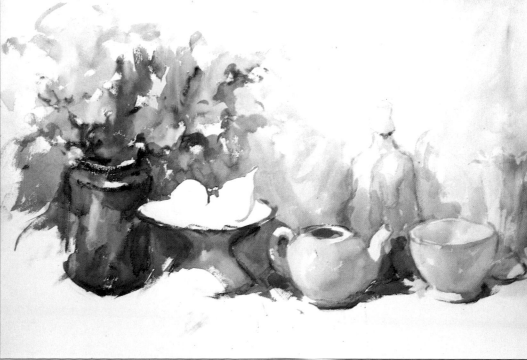

183

Fourth stage: Shadow and transparencies

185

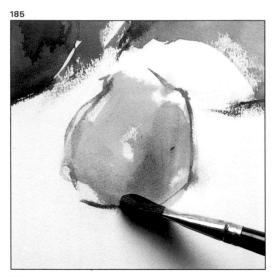

186

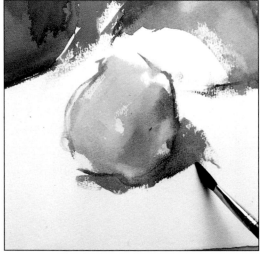

Several rounded reserves of white are left in the middle of the picture. They are the fruit that he is now going to paint.

He draws or "redraws" their outline with the bristle brush in a dark and intense ultramarine. Without waiting for this color to dry, he immediately paints with practically pure orange.

Once again, before it dries, he covers it with a warm and muted ochre that he gets by mixing orange, yellow, sienna, and a touch of blue. He adds some water and with the small, gray brush he fills out the apple with this color. Due to the typical transparency of watercolor, the areas that were reserved have a different look from those areas that were previously painted in orange. He even allows this warm color to mix with the blue of the silhouette, thus obtaining an intermediate gray. This gray relates to the apple, with its edge, and with the shadow it projects on the tablecloth.

Suddenly, Plana dips the brush in a dark color and applies several firm brushstrokes to define the separation between the background and the objects. This helps to define the volume of the objects better.

When he begins to stain the fruit on the plate, he follows more or less the same procedure.

Fig. 185. Here is a drawing in ultramarine, with a yellow and orange brushstroke. Using the edge of the brush full of yellow and sienna, Plana brings out a partial shadow.

Fig. 186. This blue shadow on the tablecloth is cast by the apple. The harmony between the yellow and blue expresses the location of the apple.

Fig. 187. The same color of the shadow is used for the apple to enhance its volume. The color mixed with the orange or the yellow produces different hues and values. With the brush, Plana absorbs the odd point of paint to express the reflections of the tablecloth on the apple.

Fig. 188. Plana has turned an apple into a pear. The shadow of the apple, cast onto the pear, is expressed in a simple but wise way: a blue plane on wet yellow. The whites still breathe through, bringing together all the areas of light in the picture.

Fig. 189. Several patches of a loose, soft gray color—a mixture of sienna with watery blue—express some shadows or wrinkles in the white tablecloth in the foreground.

187

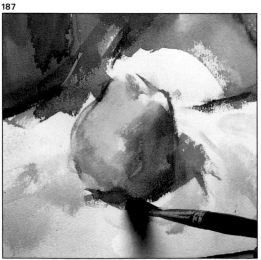

188

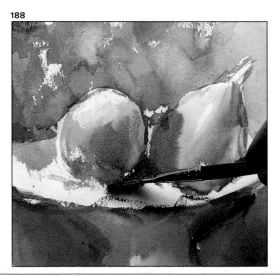

Fig. 190. Here is the almost finished picture, with the relationships of light and shadow clearly defined. The colors, harmoniously combined, create space, depth, and atmosphere. Some objects are outlined, others are not. There is richness in the variety of skills used, and in the picture's tonalites and qualities, some transparent and others dense.

He applies large brushstrokes that act like planes, defining and creating volume, separating the light from the shadow very clearly.

Freshness, fluency, and spontaneity: together they create a synthesis that is always abstract, pictorial, and free. The results are not restricted to reality itself, but express a reality through the relationship between the different elements.

Finally, he stains the cloth in the foreground with the round squirrel-hair brush. He uses a gray between indigo and sienna, and dilutes it with a general gouache that moves in toward the parts of the background that are still not painted. He only hints at the wrinkles in the tablecloth with large, rubbed, loose strokes that reserve white points and achieve the warmth of the cloth.

189

190

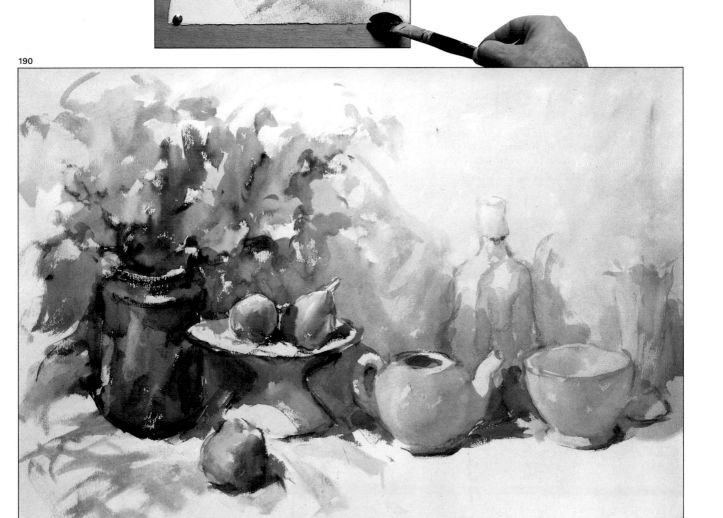

Fifth and last stage: White is a color

Although we have added a fifth stage to this watercolor, you will note that there have been few changes. The previous stage is, in fact, almost a "prefinished version." Nevertheless, this will allow us to better observe the finished and signed watercolor as a whole. It also gives us the opportunity to observe how Manel Plana gives an odd, almost invisible "touch," with a watery warm color to make a separation firmer. Insisting that he has painted this theme several times, Plana warns us: "Nothing comes without an effort; we must never think we know it all. It's necessary to work hard, to try out many things. We can't "feel brave," because watercolor—and painting in general—holds many surprises, and we always have to be on the lookout for what is required of us. Because the paper, the color, and the brush have their own path, and we shouldn't think we can force them to go where we want when, perhaps, it's too late." As we can see, painting is constantly "communicating" with the work, and painting is also practicing, experimenting, and really working.

This watercolor makes the best possible use of white. The white of the paper is of fundamental importance. Plana is interested in contrasts and strong light so he prepares the setup, when it is a still life, to obtain these effects. Clean, white objects,

191

192

194

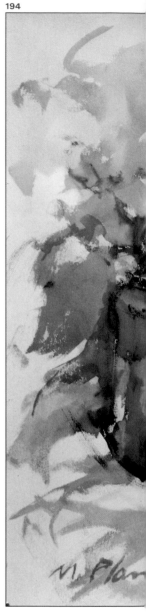

illuminated by a strong light, shine and broaden with the light, as if they had a halo of light. Plana is, without a doubt, a fantastic painter of light. His watercolors are brilliant, luminous works with a large number of perfectly integrated whites that create the composition of the theme, as much, if not more than, color. This magnificent watercolor that you and I observed being painted is only one example of the consistent, beautiful, open, and luminous work of Manel Plana.

193

Figs. 191 and 192. Throughout the entire process, Plana has been continuously cleaning the brush. Notice that to drain the brush, he grasps it with his hand, letting it drip onto the floor. The floor, as you can see, is covered with stains by the end of this painting session.

Fig. 193. Manel Plana signs the work with the narrowest flat brush, considering the picture now finished.

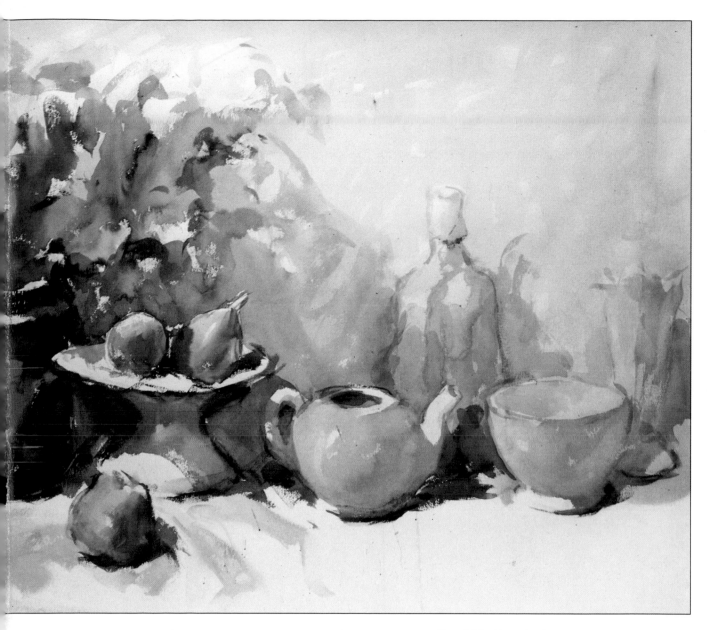

Fig. 194. Here is the finished and signed picture. Perhaps you will be able to spot some differences between this and the previous stage, but we warn you that there are practically none at all. Plana has spent a good while concentrating and observing his watercolor, but has ultimately decided to let it stay as it is. In fact, we believe that this is how it should be. The watercolor is lovely, impressive in size, and as freshly finished as possible. It has all been achieved by means of knowing how to mix the whites of the paper with the paint in order to create a luminous effect that is characteristic of the light on white objects.

Contents